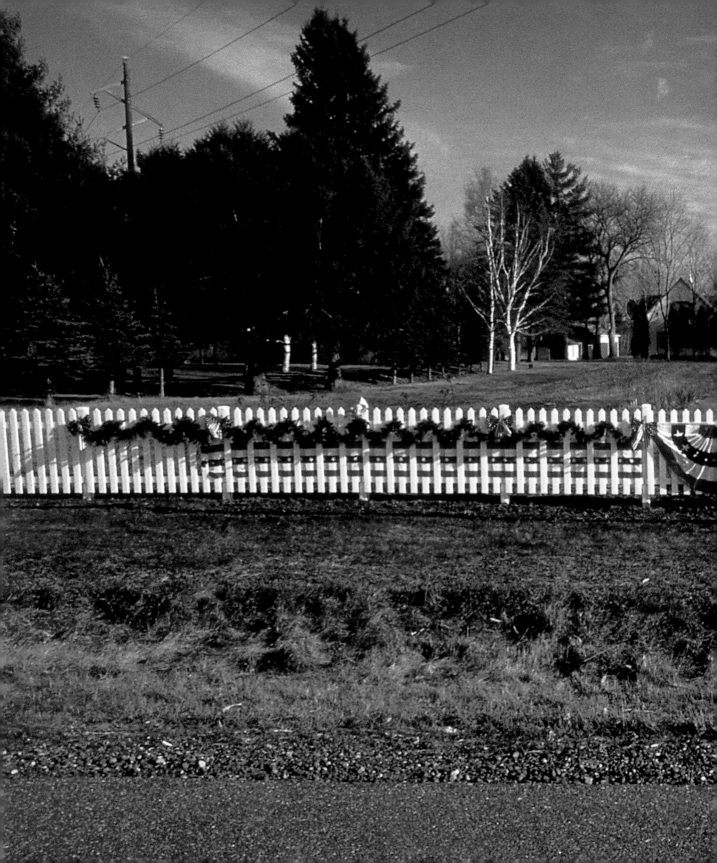

Northland Spirit

by Michael Peterson

Adventure Publications, Inc.
Cambridge, Minnesota

Book Design by Jonathan Norberg

Copyright 2002 by Michael Peterson
ISBN 1-885061-40-4
Published by Adventure Publications, Inc.
820 Cleveland St. S
Cambridge, MN 55008
1-800-678-7006
Printed in China

To Meta.
I hope you enjoy this.
For God & Country!
"2002"
Mike Peterson

Dedication

This book is for and about the Patriots who displayed their love
of country, and for their fellow Americans who bore the brunt of the
9-11-01 attacks.

Introduction

Northland Spirit began while I was traveling and working on other projects. Shortly after the September 11th attacks, the patriotic displays that popped up everywhere so impressed me that I began to photograph them. At first, I shared the results with my family. From this grew a great desire to share them with others, as the folks who created them wanted them to be seen. Many of us felt as if we could not help, but what we could do was put up the flag—our shining beacon of freedom!—for those who suffered most and in support of our service members. The historical quotes and poetry have been added to enhance learning, invoke gratitude for the freedom God has granted us, and inspire patriotism in our Country.

Mike Peterson

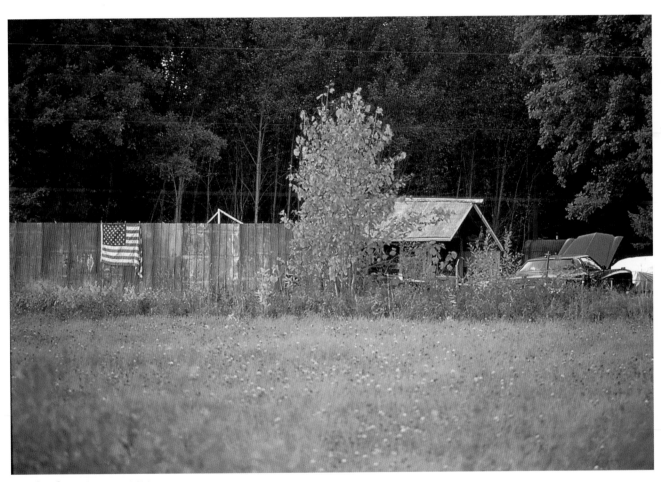

North of McGregor, MN

Our Flag

You may call it an old piece of bunting;
You may call it an old tattered rag;
But thousands have died for its honor,
And shed their best blood for the flag.

You may call it an old piece of bunting;
You may call it an old tattered rag;
But freedom has made it majestic,
And time has ennobled Our Flag.

Author Unknown

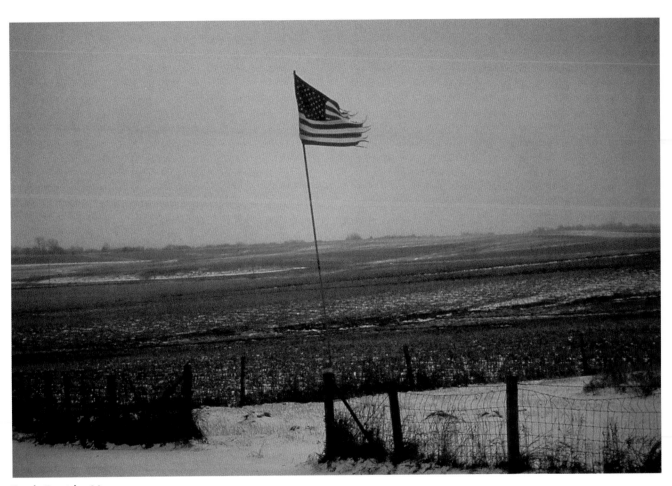

Rock Rapids, IA

Providence has showered on this land, blessings without number and has chosen you as the guardians of freedom to preserve it for the benefit of the human race. May He who holds in His hands the destinies of nations make you worthy of the favors He has bestowed and enable you with pure hearts and hands and sleepless vigilance to guard and defend until the end of time that great charge He has committed to your keeping.

President Andrew Jackson's Farewell Address

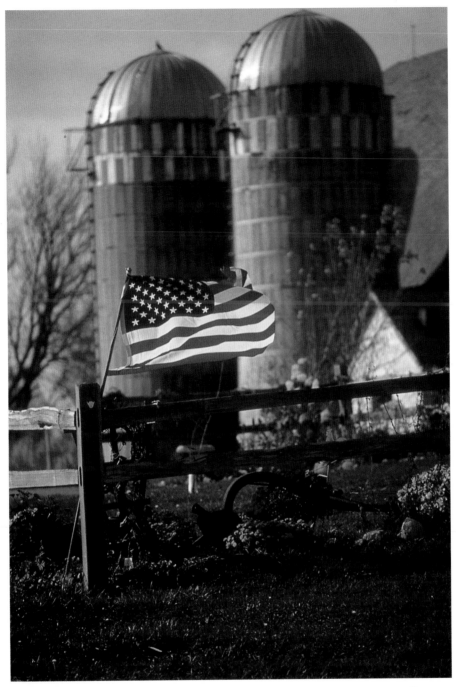

Waconia, MN

I pledge allegiance to the Flag of the United States of America
and to the Republic for which it stands,
one nation under God,
indivisible,
with liberty and justice for all.

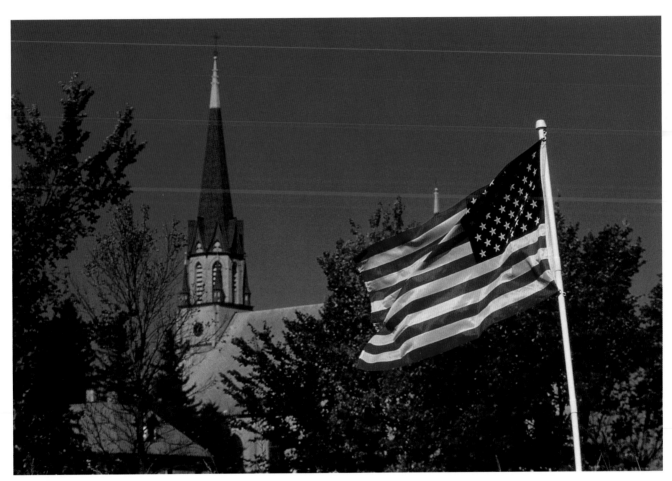

Freeport, MN

We like living right, and being free.

Merle Haggard

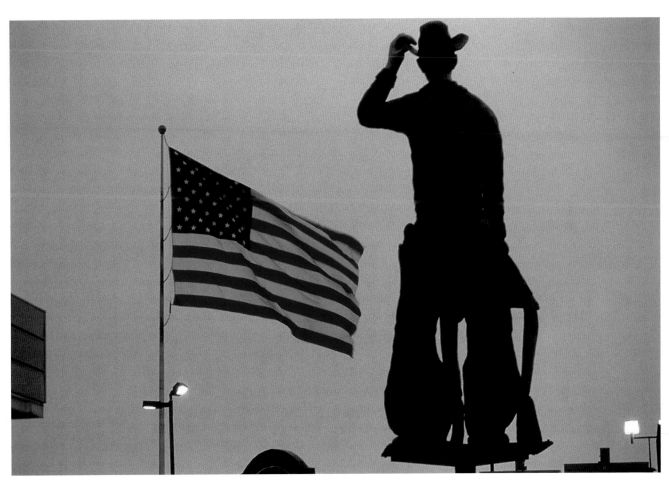

Watertown, SD

I felt red, white, and blue all over.

U. S. astronaut Edward H. White II,
on his walk in space

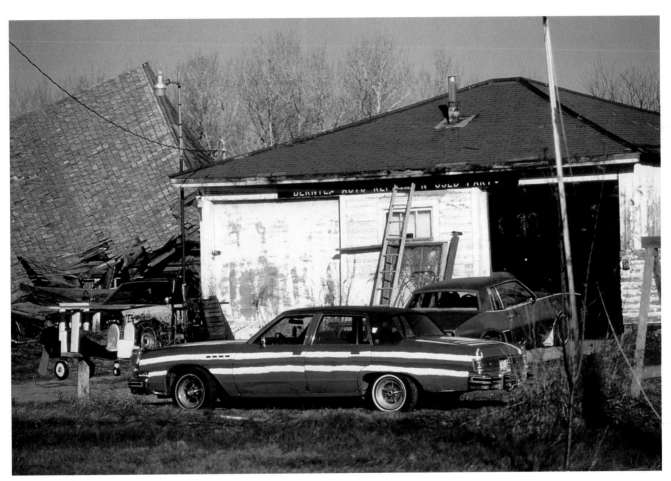

Hackensack, MN

Flag of Our Hearts

Flag of our hearts is waving high,
From sea to sea it cheers the eye,
Though stretches wide this goodly land,
Beneath its folds all safely stand.

May we this dear old flag so prize,
That evermore our prayers may rise,
Oh! may it stand for all things pure,
And ever keep the truth secure.

Then lift the hand and bow the head,
While words of loyal love are said
And may there never hand be found
To trail its glory on the ground.

Be this its mission evermore,
To spread sweet peace from shore to shore,
Then bow the head and lift the hand.
While neath its folds secure we stand.

Clara J. Denton

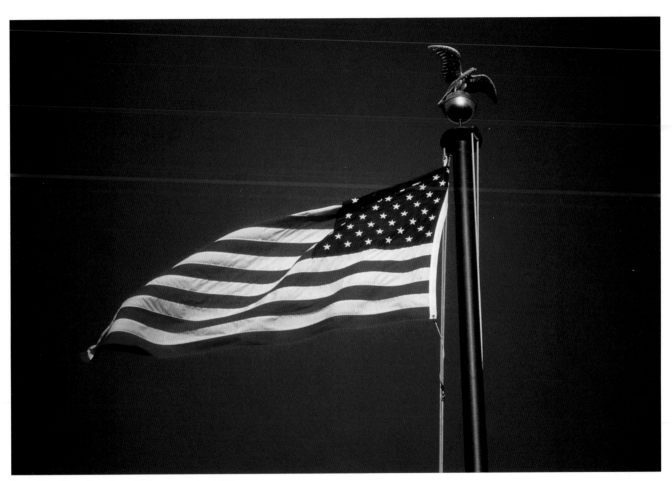

Fort Snelling National Monument, MN

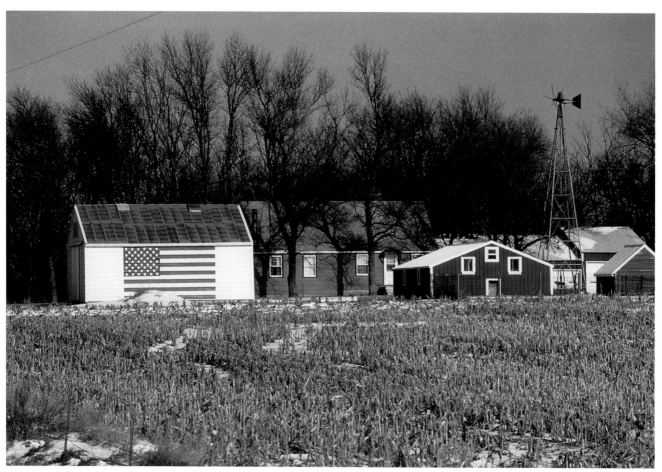

Flandreau, SD

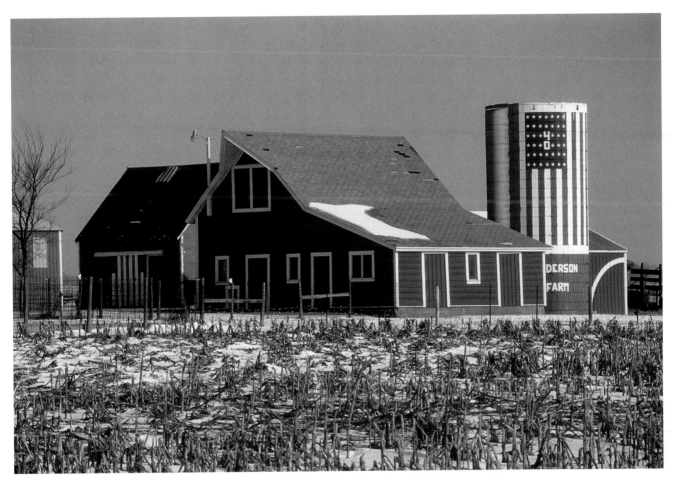

Flandreau, SD

Peace is not made by compromise.
It does not grow out of expediency.
Peace is not a flower growing in the world's flower garden.
It is rather a product of the blacksmith's forge—
 hammered out on the anvils of sacrifice and suffering...
 heated in the fires of devotion to righteousness...
 tempered in the oil of mercy and goodness...
Peace is a costly thing.

Peter Marshall, chaplain of the Senate 1947-1949

Bayport, MN

For those who fight for it, freedom has a flavor the protected never know.

Written on a C-ration box
found after the siege of Khe Sahn, 1968

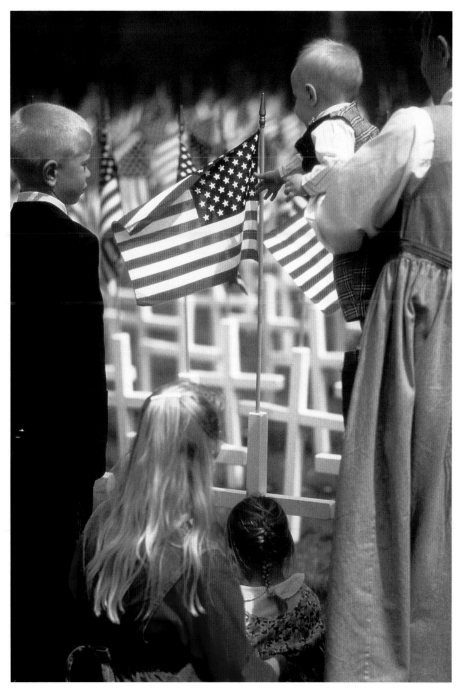

Hackensack, MN

This great nation will endure as it has endured,
will revive and prosper.
…The only thing we have to fear is fear itself.
…We face arduous days that lie before us in the warm courage
of national unity;
with the clear consciousness of seeking old and precious moral values.

President Franklin Delano Roosevelt

Albert Lea, MN

Elk River, MN

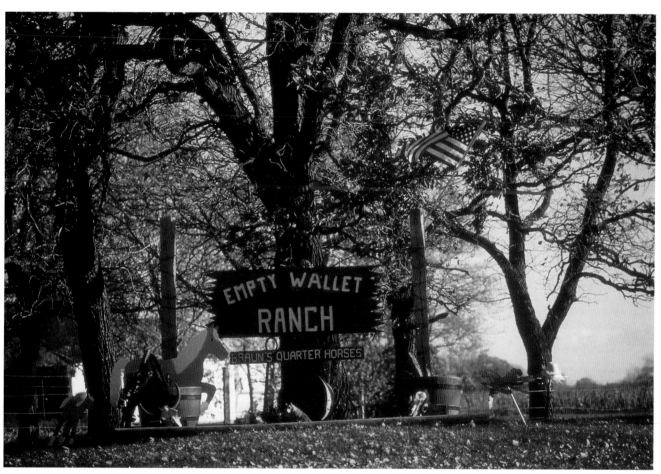

Clearwater, MN

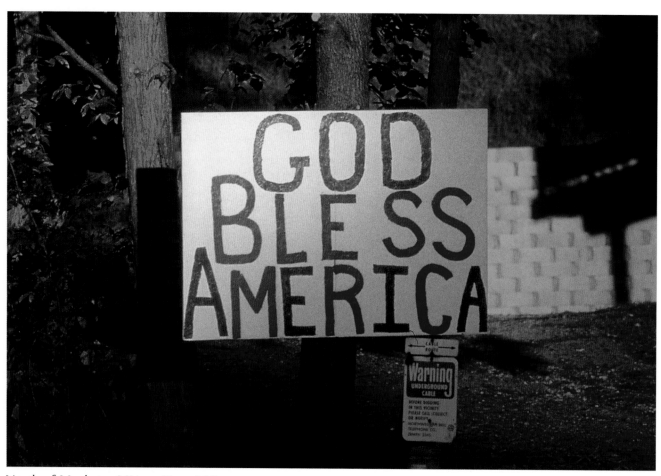

North of Mankato, MN on Hwy. 169

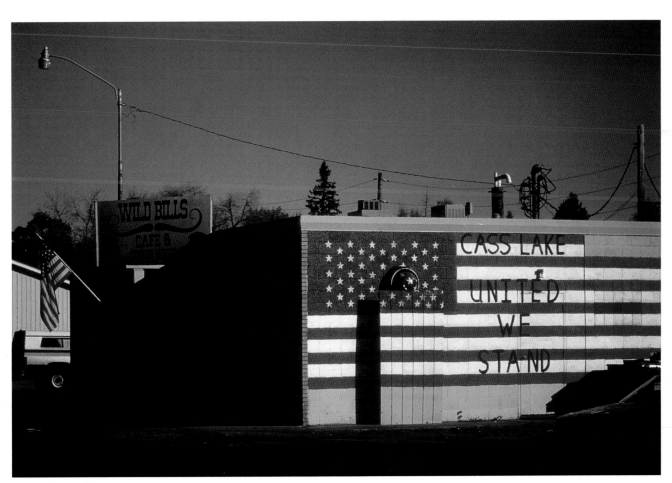

Cass Lake, MN

Americanism means the virtues of
courage,
honor,
justice,
truth,
sincerity,
and hardihood—
the virtues that made America.

President Teddy Roosevelt

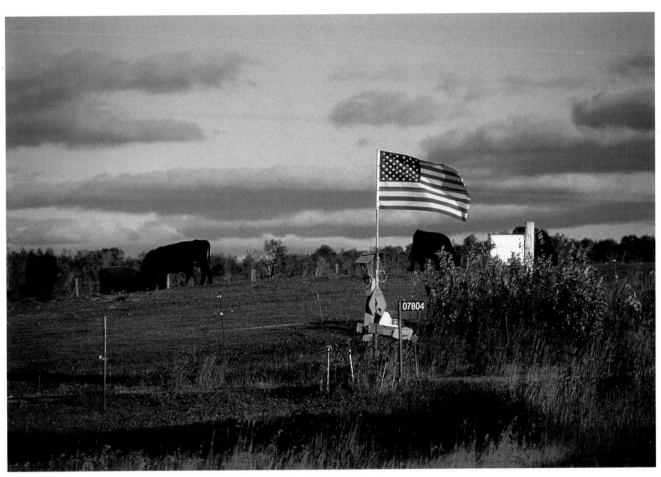

Remer, MN

Proclaim liberty throughout all the land unto all the inhabitants thereof.

Leviticus 25:10, engraved on the Liberty Bell

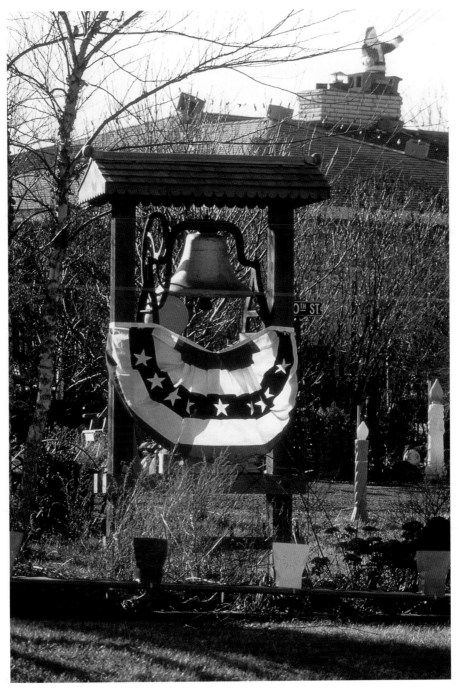

Almelund, MN

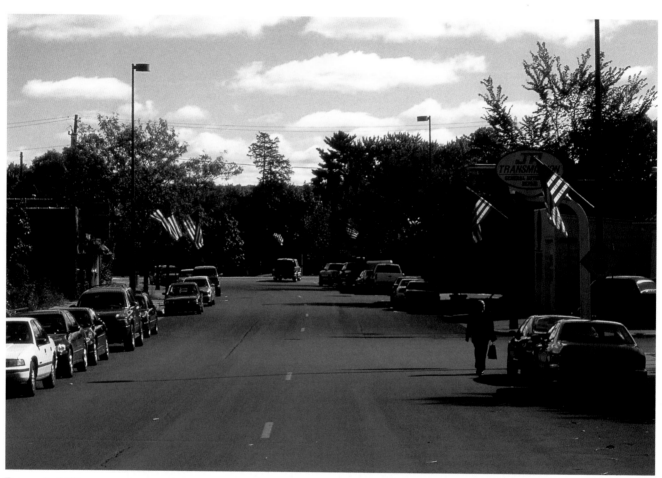

Bayport, MN

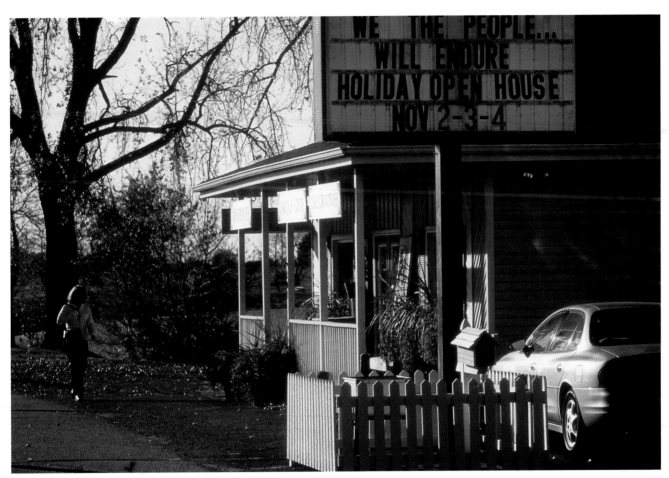

Big Lake, MN

Patriotism is that love for country in the hearts of the people which shall make that country strong to resist foreign opposition and domestic intrigue—which impresses each and every individual with a sense of the inalienable rights of others and prepares him to accept the responsibility of protecting those rights.

American Tribune, March 7, 1890

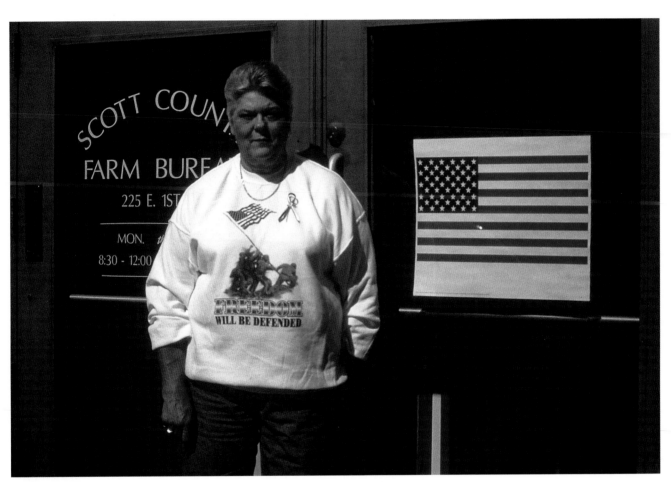

Jordan, MN

The things that the flag stands for were created by the experiences of a great people. Everything that it stands for was written by their lives. The flag is the embodiment, not of sentiment, but of history. It represents the experiences made by men and women, the experiences of those who died and lived under that flag.

President Woodrow Wilson

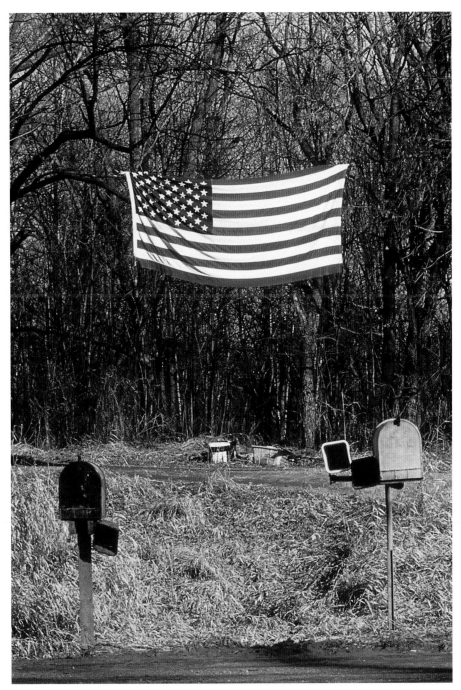

Cambridge, MN

"And for your country, boy, and for that flag, never dream a dream but of serving her as she bids you, though the service carry you through a thousand hells. No matter what happens to you, no matter who flatters you or who abuses you, never look at another flag, never let a night pass but you pray God to bless that flag. Remember, boy, that behind all these men you have to do with, behind officers, and government, and people even, there is the Country Herself, your Country, and that you belong to her..."

Philip Nolan in The Man without a Country
by Edward Everett Hale

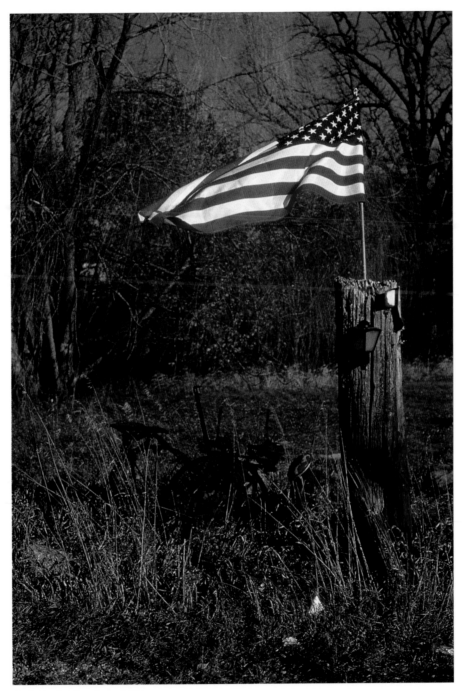

Oak Park Heights, MN

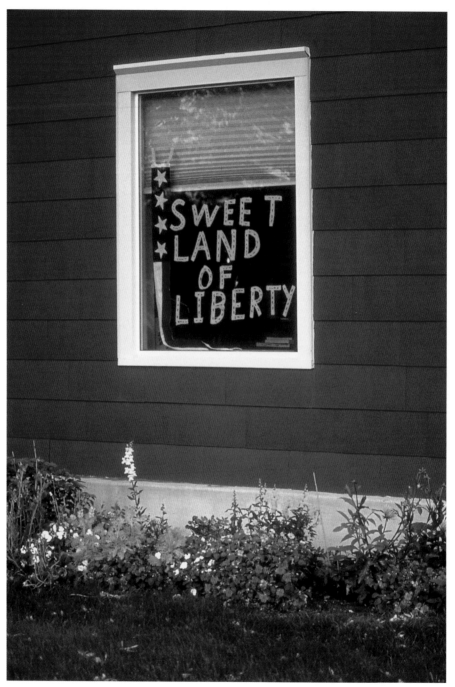

St. Peter, MN

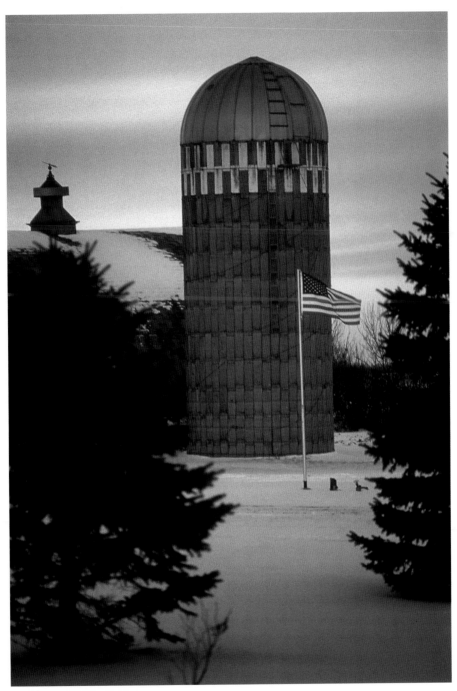

Ambercrombie, ND

My red stripes proclaim
the fearless courage of American men and boys
and the self-sacrifice and devotion of American mothers and daughters.

Ruth Apperson Rous

Stillwater, MN

My white stripes stand for liberty and equality for all.

Ruth Apperson Rous

Alexandria, MN

My blue is the blue of
heaven,
loyalty,
and faith.

Ruth Apperson Rous

Duluth, MN

Stillwater, MN

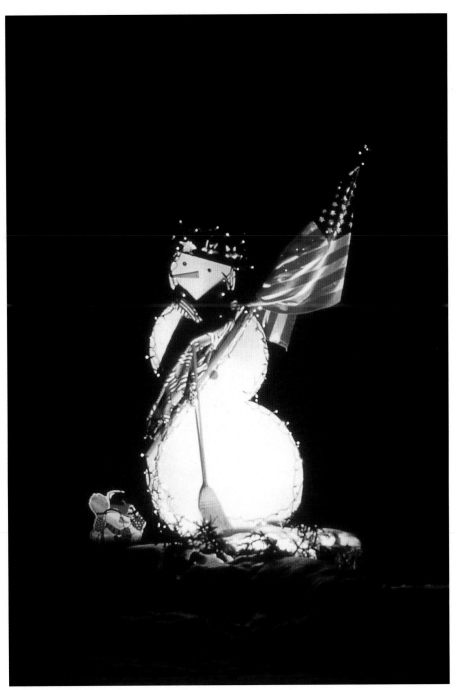

Hackensack, MN

Flag Day

Boy, bare your head when the flag goes by!
Girl, look your loyalty as it waves!
Those stars came out in a splendid sky
Over your forefathers' gallant graves;
Those stripes were fastened by heroes' hands;
Those colors flash out to the farthest lands.
A bit of bunting, but how it gleams,
Fashioned of valor and woven of dreams.
The wind's in its folds, they are lifting high;
Oh, lift your hearts as the flag goes by!

Nancy Byrd Turner

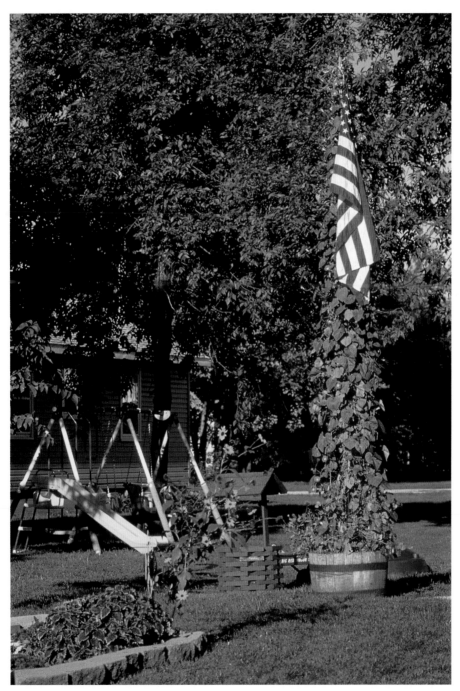

St. Peter, MN

Today, our way of life,
our very freedom came under attack
in a series of deliberate and deadly terrorist acts.
These acts shattered steel
but they cannot dent the steel of American resolve.

President George W. Bush

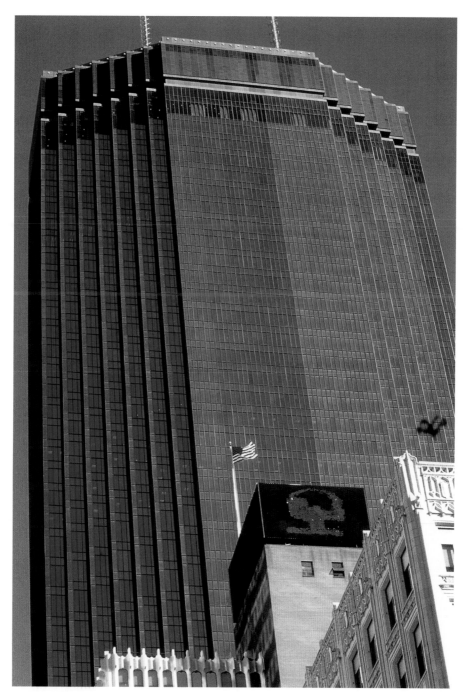

Minneapolis, MN

So it's home again, and home again, America for me!
My heart is turning home again, and there I long to be,
In the land of youth and freedom beyond the ocean bars,
Where the air is full of sunlight and the flag is full of stars.

Henry Van Dyke

Walker, MN

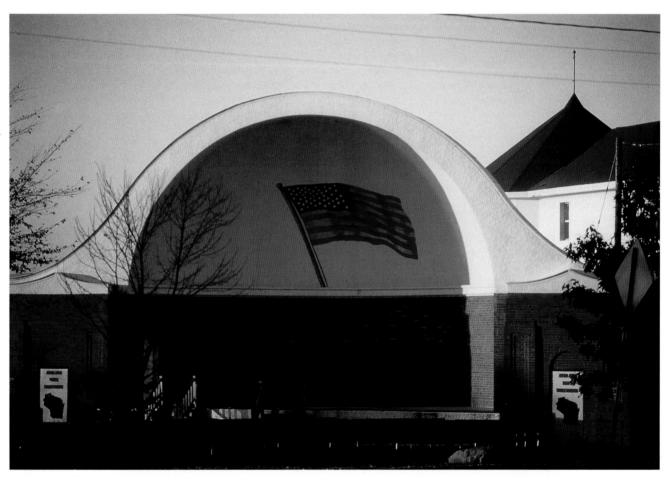

Ashland, WI

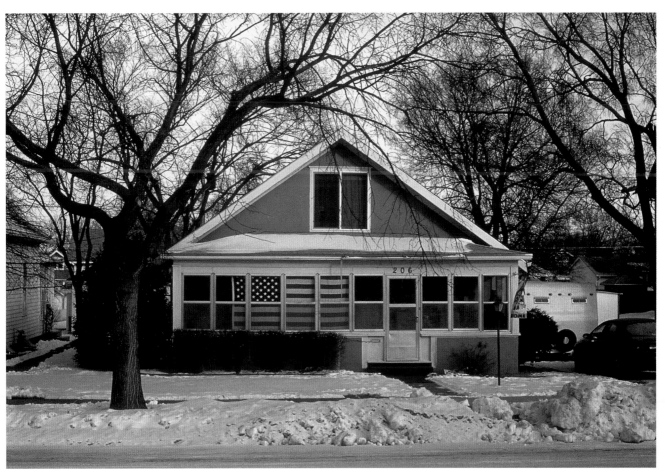

Flandreau, SD

As you see me silhouetted against the peaceful skies of my country, remind yourself that I am the flag of your country, that I stand for what you are—no more, no less.

Ruth Apperson Rous

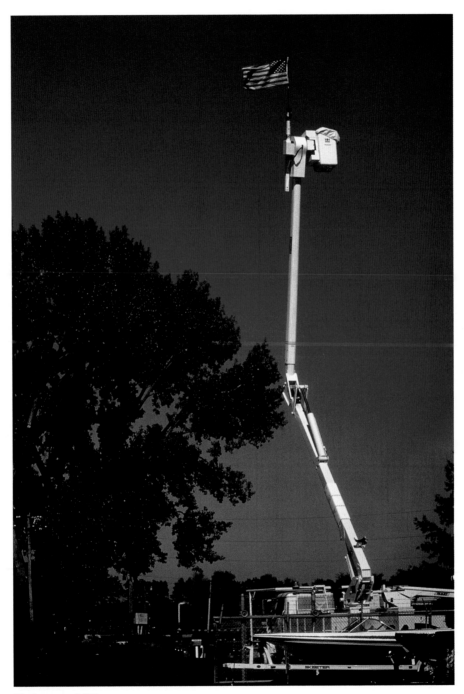

Shakopee, MN

We do honor to the stars and stripes as the emblem of our country and the symbol of all that our patriotism means.

We identify the flag with almost everything we hold dear on earth. It represents our peace and security, our civil and political liberty, our freedom of religious worship, our family, our friends, our home. We see it in the great multitude of blessings, of rights and privileges that make up our country.

But when we look at our flag and behold it emblazoned with all our rights, we must remember that it is equally a symbol of our duties. Every glory that we associate with it is the result of duty done.

President Calvin Coolidge

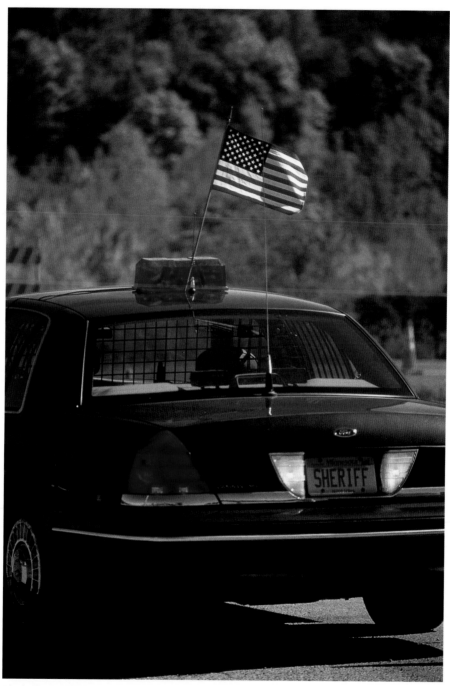

Shakopee, MN

Oath of Office for United States Military Personnel

...I do solemnly swear that I will support and defend the constitution
of the United States of America against all enemies, foreign and domestic,
that I will bear true faith and allegiance to the same;
that I take this obligation freely,
without any mental reservation or purpose of evasion;
and that I will well and faithfully discharge the duties of the office
upon which I am about to enter; so help be God.

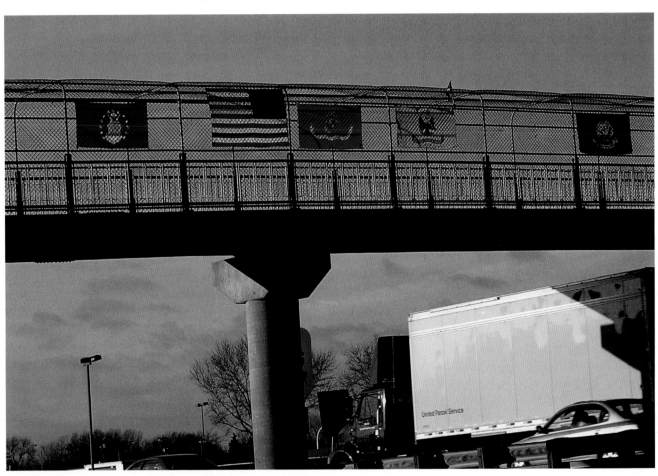

Interstate 494 overpass, Minneapolis, MN
Flags from L to R: Air Force, US, Marine, Army, Navy

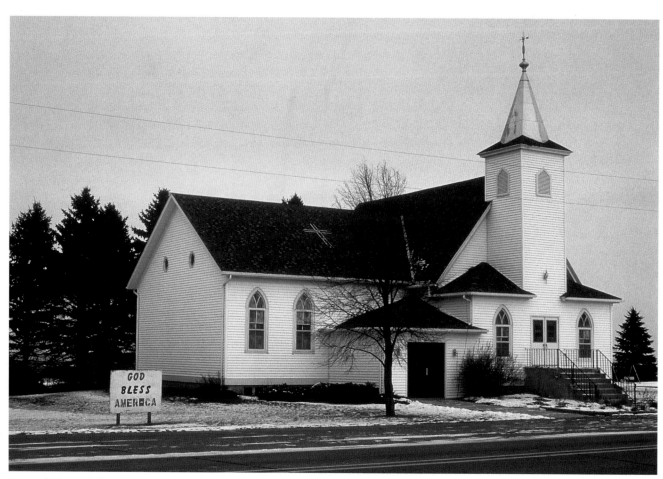

East of Sioux Falls, SD

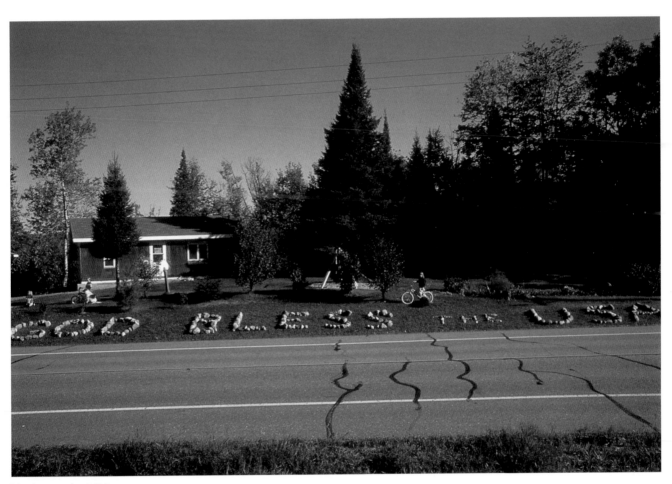

Hackensack, MN

I Am Your Flag

I am the silent sentinel of Freedom.
I am the emblem of the greatest sovereign nation on earth.
I am the inspiration for which American Patriots gave their lives and fortunes.
I have led your sons into battle from Valley Forge to the bloody swamps of Vietnam.
I walk in silence with each of your Honored Dead,
to their final resting place beneath the silent White Crosses, row upon row.
I have flown through Peace and War, Strife and Prosperity,
and amidst all I have been respected.
My Red Stripes... symbolize the blood spilled in defense of this glorious nation.
My White Stripes... signify the burning tears shed by Americans who lost their sons.
My stars... clustered together, unify 50 States as one, for God and Country.
"Old Glory" is my nickname, and proudly I wave on high.
Honor me, respect me, defend me with your lives and fortunes.
Never let my enemies tear me down from my lofty position, lest I never return.
Keep alight the fires of patriotism, strive earnestly for the spirit of democracy.
Worship Eternal God and keep His commandments,
and I shall remain the bulwark of peace and freedom for all mankind.
I am your flag.

written by a Marine

Brookings, SD

Posterity—you will never know how much it has cost my generation to preserve your freedom. I hope you will make good use of it.

President John Quincy Adams

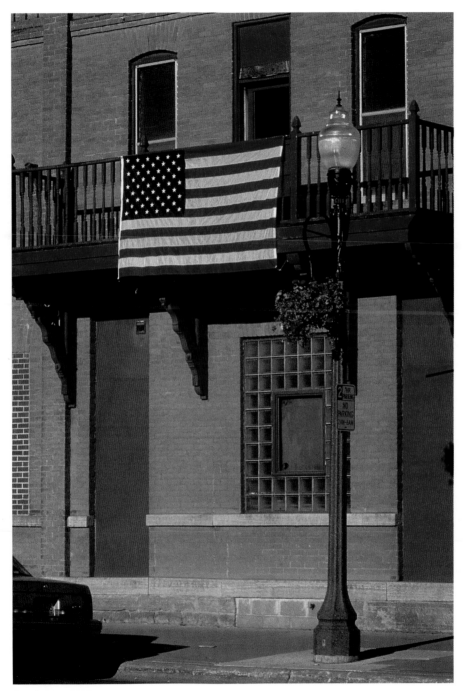

St. Peter, MN

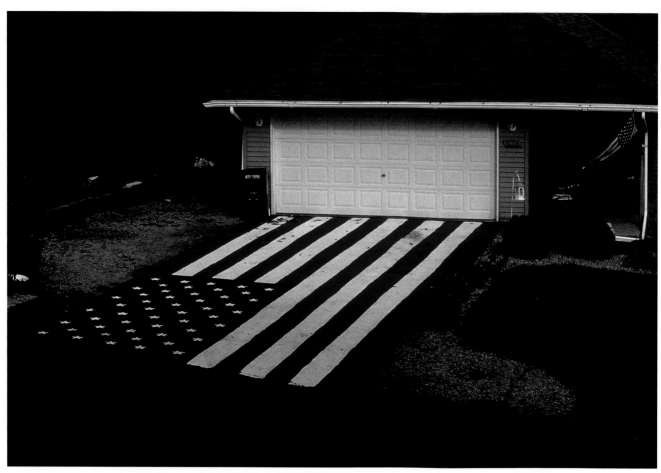

Hastings, MN

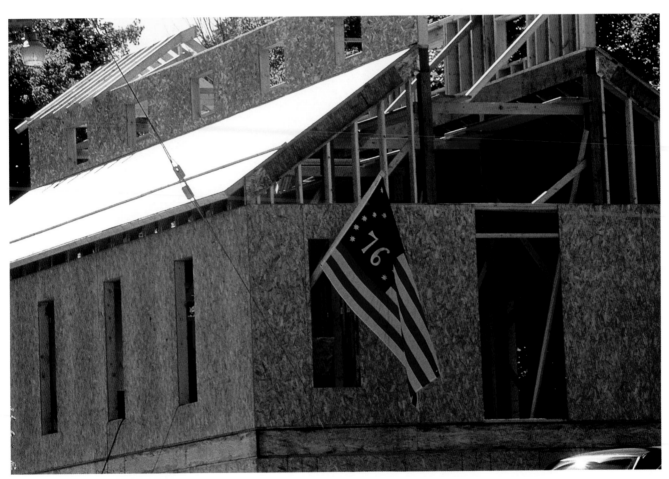

Stillwater, MN

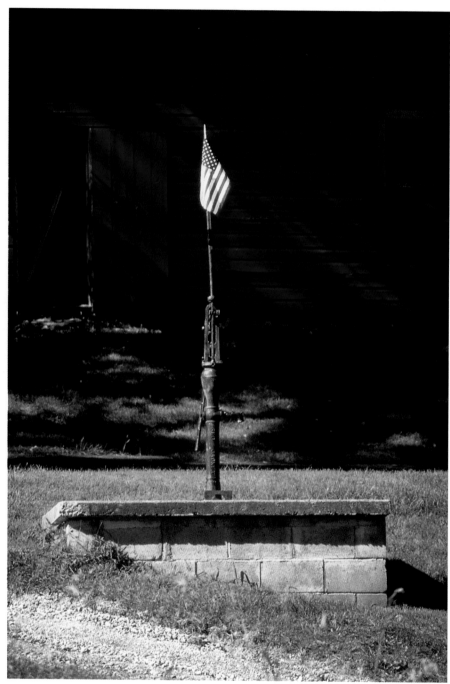

Henderson, MN

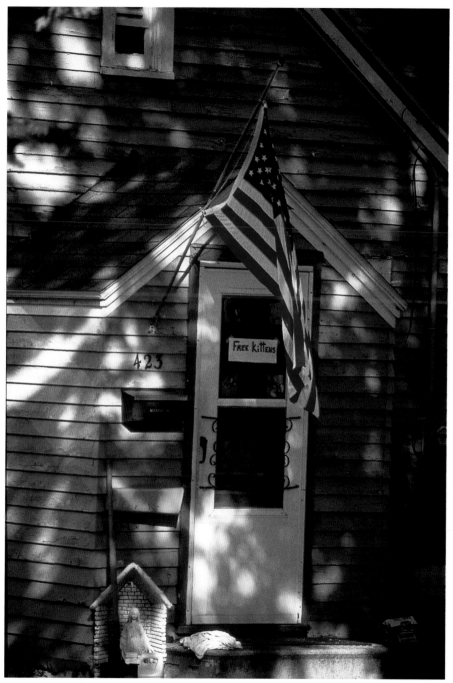

Albert Lea, MN

This is my country, and I believe in her, and I believe in her flag, and I'll defend her and I'll fight for her and serve her. If she has any ills, I'll stand by her and hold her hand until in God's given time, through her wisdom and her consideration for the welfare of the entire nation, things are made right again.

General Daniel "Chappie" James

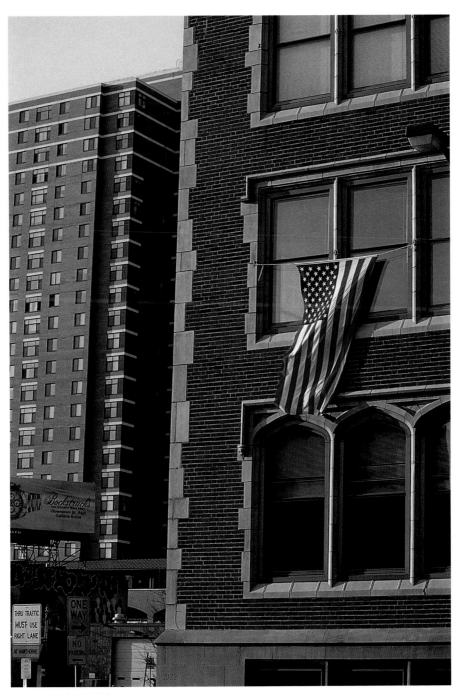

Minneapolis, MN

Gold is good in its place
but living, brave, patriotic men are better than gold.

President Abraham Lincoln

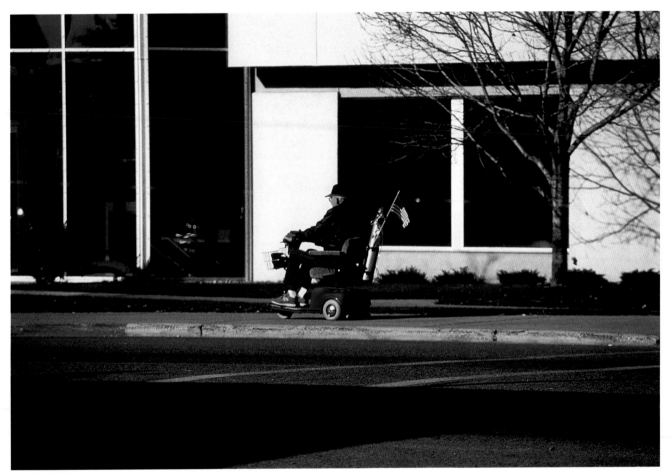

Walker, MN

When you go home
Tell them for us and say
For your tomorrow
We gave our today

chiseled outside the cemetery

on Iwo Jima

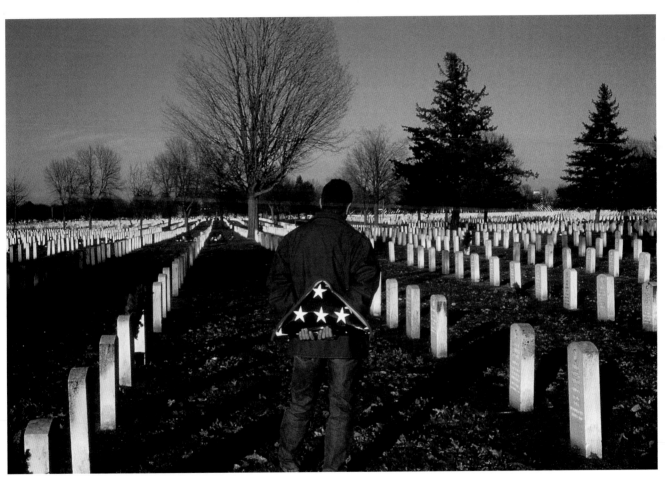

Fort Snelling National Cemetery, MN

And so my fellow Americans, ask not what your country can do for you,
ask what you can do for your country.
My fellow citizens of the world, ask not what America can do for you,
but what together we can do for the freedom of man.

engraved on granite near President John F. Kennedy's grave,

from his inaugural address

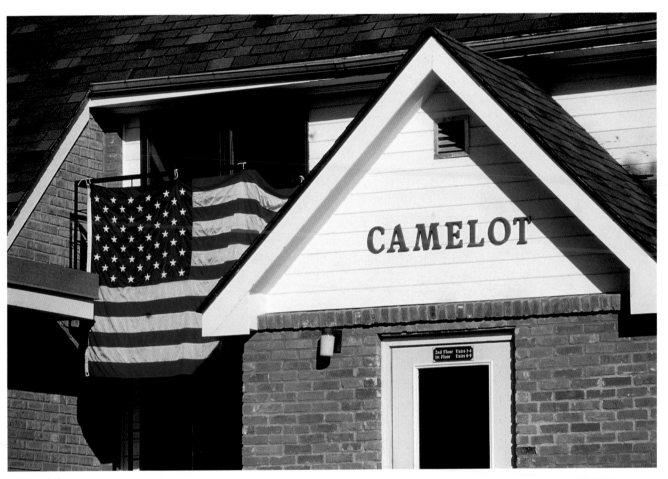

Annandale, MN

Our fathers and grandfathers who poured over the Midwest were self-reliant, rugged, God-fearing people of indomitable courage…. They asked only for freedom of opportunity and equal chance. In these conceptions lies the real basis of American democracy. They and their fathers give a genius to American institutions that distinguished our people from any other in the world.

President Herbert Hoover

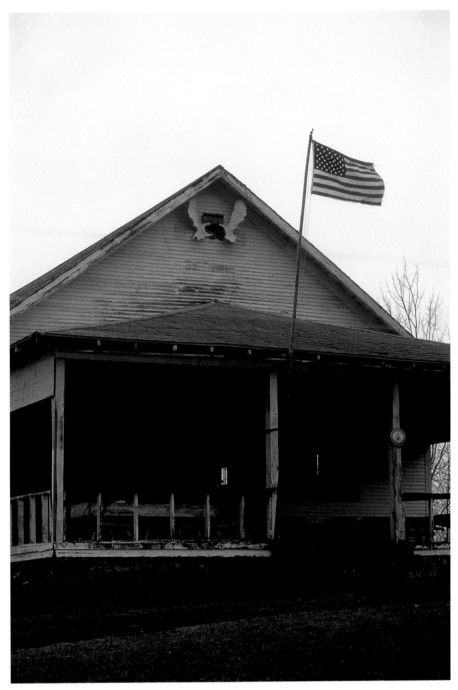

Brookston, MN

Patriotism is easy to understand in America;
it means looking out for yourself by looking out for your country.

President Calvin Coolidge

Bowlus, MN

Henderson, MN

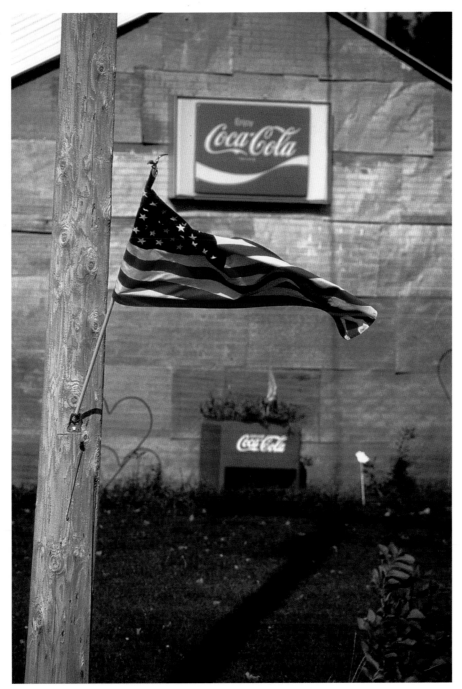

Albert Lea, MN

A nation's destiny
is not in its learning
or the amount of information it acquires—
it's in its character.

Julley

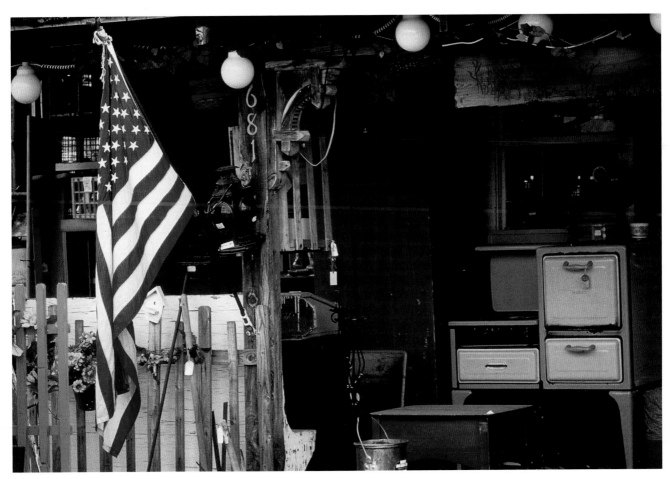

Motley, MN

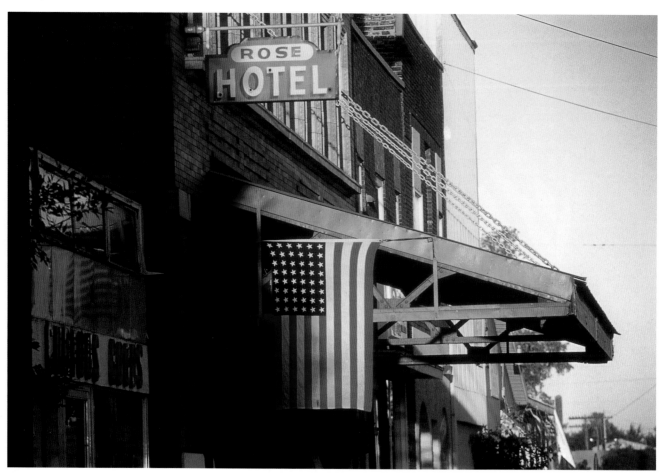

Superior, WI

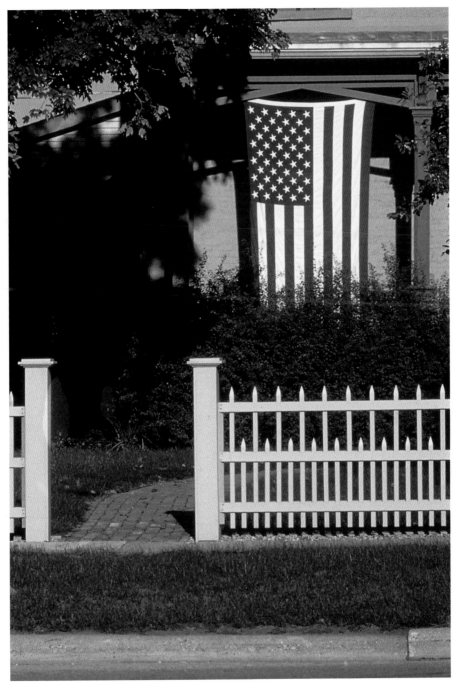

St. Peter, MN

This is a day when all Americans from every walk of life united in our resolve
for justice and peace.
America has stood down enemies before, and we will do so this time.
None of us will ever forget this day.
Yet we go forward to defend freedom and all that is good and just in our world.

Great tragedy has come to us,
and we are meeting it with the best that is in our country,
with courage and concern for others.
Because this is America. This is who we are.

In all that lies before us,
may God grant us wisdom,
and may he watch over the United States of America.

President George W. Bush

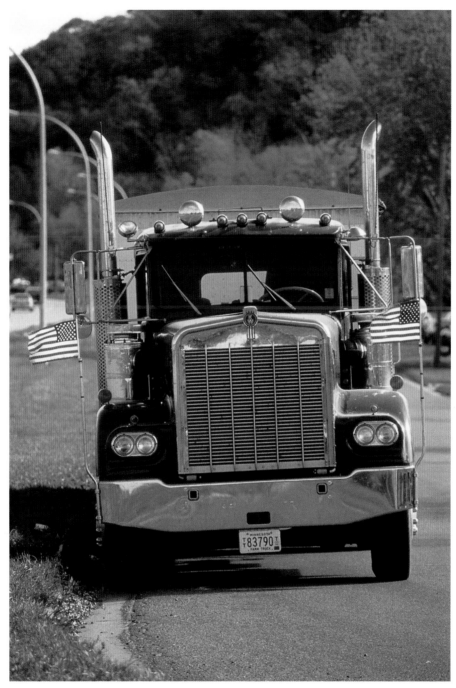

Red Wing, MN

The American's Creed

I believe in the United States of America as a government of the people, by the people, for the people; whose just powers are derived from a sense of the governed; a democracy in a Republic; a sovereign Nation of many sovereign States; a perfect Union, one and inseparable; established upon those principles of freedom, equality, justice, and humanity for which American patriots sacrificed their lives and fortunes.

I therefore believe it is my duty to my country to love it; to support its Constitution; to obey its laws; to respect its flag; and to defend it against all enemies.

William Tyler Page

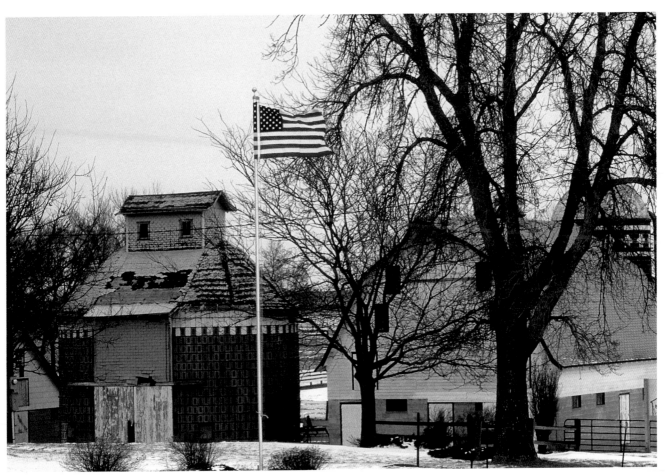

Lester, IA

Thank God, I—I also—am an American!

Daniel Webster

Portland Avenue, Minneapolis, MN

The immigrants that came here did not come with wealth, they came with hope. The immigrants that came to these shores and built this America did not come with freedom, they came looking to find it.

Vice President Hubert H. Humphrey

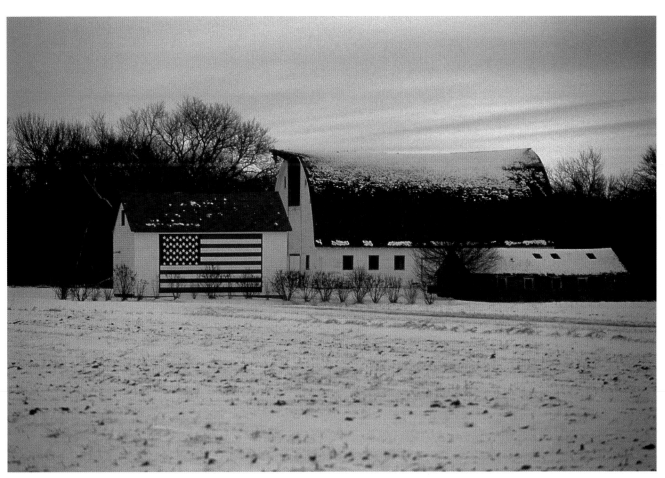

Abercrombie, ND

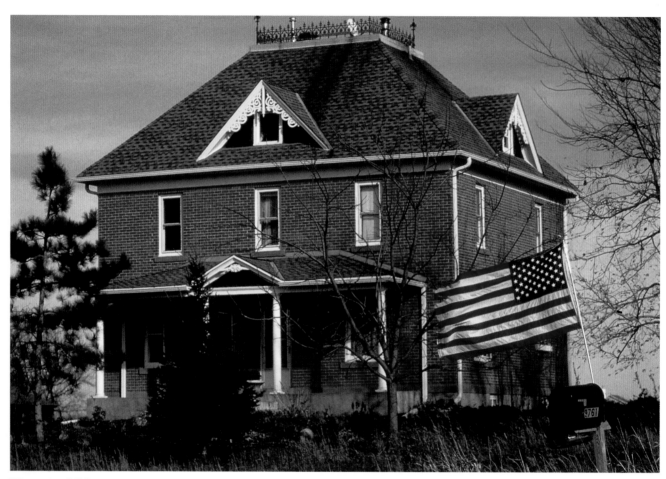

Waconia, MN

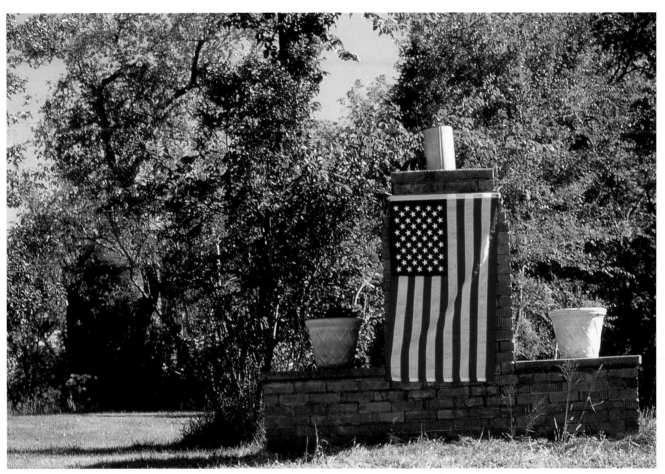

White Bear Lake, MN

It has been the special blessing of this land that each generation of Americans has called its own cadence and written its own music. Our greatest songs are still unsung.

Vice President Hubert H. Humphrey

Alexandria, MN

To do anything great requires time, patience, and perseverance.

W. J. Wilmont Buxton

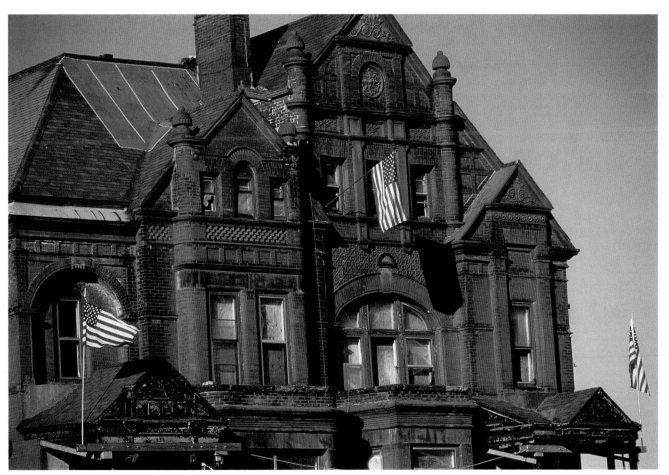

St. Paul, MN

I slept, and dreamed that life was Beauty;
I woke, and found that life was Duty.

Ellen Sturgis Hooper

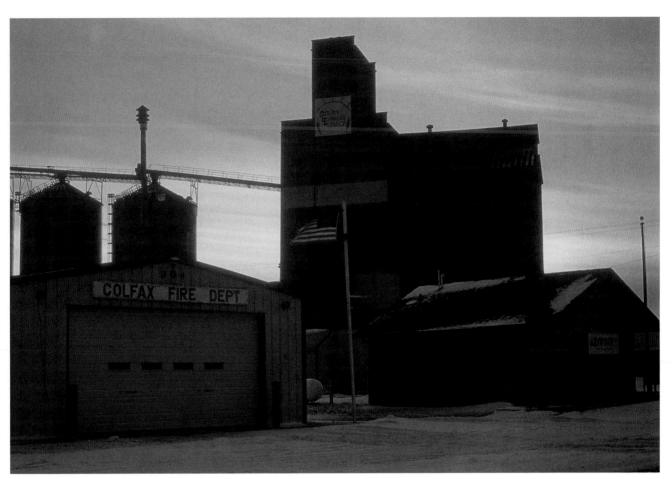

Colfax, ND

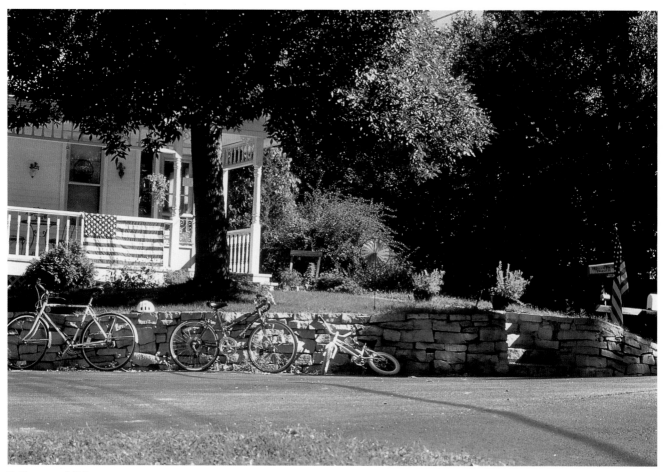

Stillwater, MN

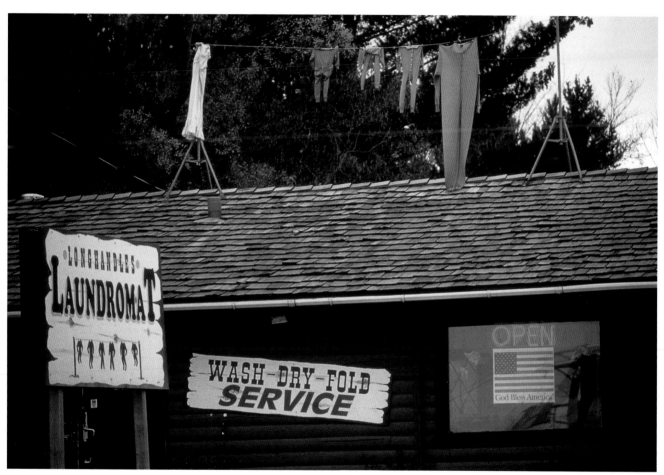

Park Rapids, MN

We are ready except that we have no suitable ensign to display over the Star Fort, and it is my desire to have a flag so large that the British will have no difficulty in seeing it from a distance.

Major George Armistead, commandant of Fort McHenry

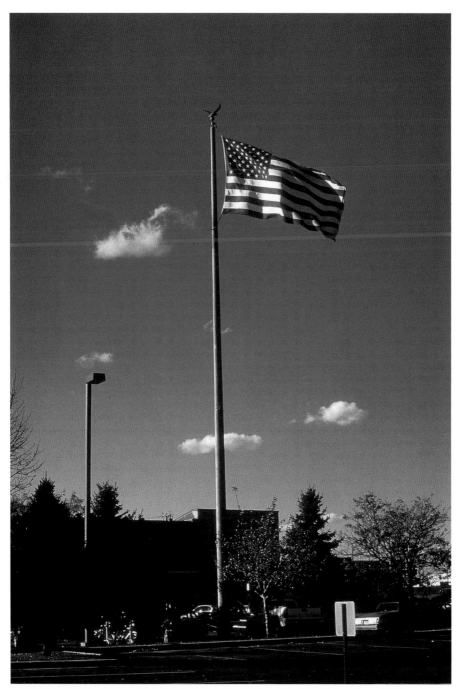

Elk River, MN

In great deed something abides.
On great fields something stays.
Forms change and pass;
bodies disappear; but spirits linger,
to consecrate ground for the
vision-place of souls.

And reverent men and women from afar,
and generations that know us not
and that we know not of,
heart-drawn to see where and by whom
great things were suffered and done for them,
shall come to this deathless field
to ponder and dream;

And lo! the shadow of a mighty presence
shall wrap them in its bosom,
and the power of the vision pass into their souls.

Joshua Lawrence Chamberlain,

on revisiting the battlefield at Gettysburg

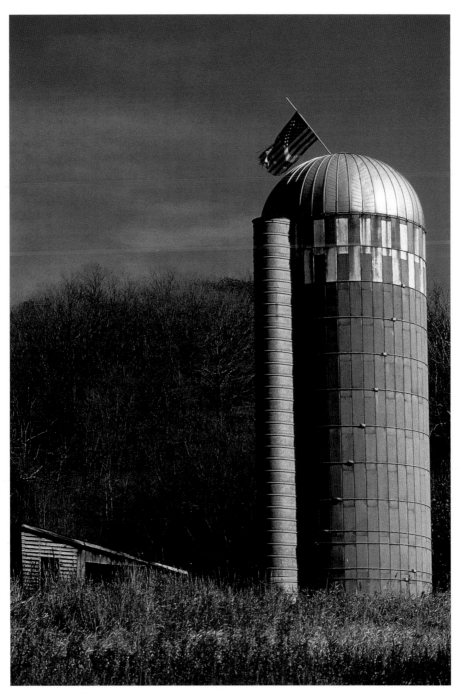

Shakopee, MN

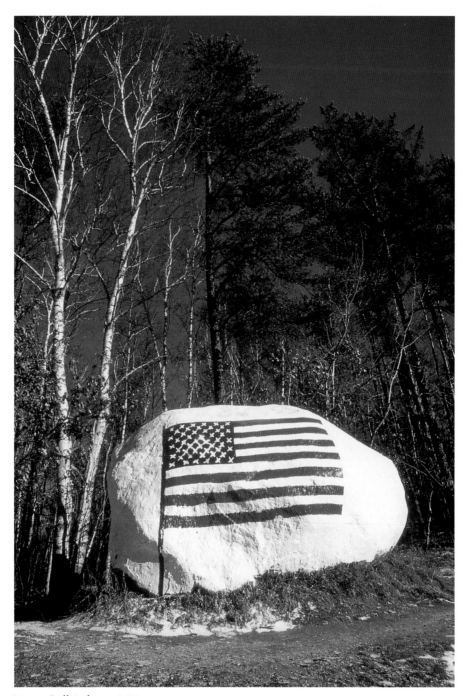

Near Gull Lake in MN

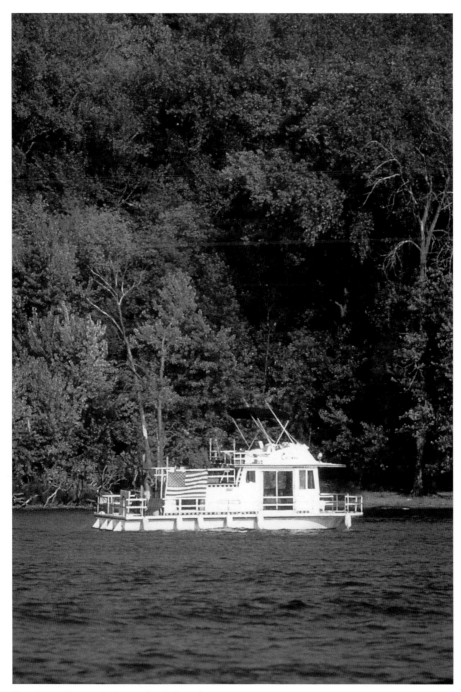

St. Croix River, MN and WI border

My fellow citizens, our nation is poised for greatness.
We must do what we know is right and do it with all our might.

President Ronald Reagan

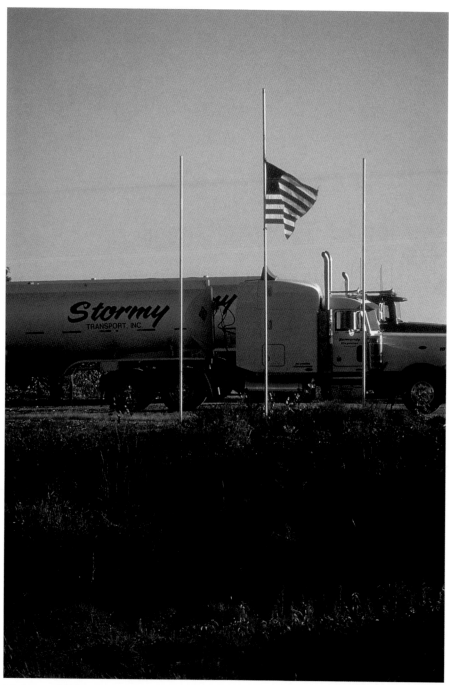

Melrose, MN

A Star for every State, and a State for every Star.

Robert Charles Winthrop

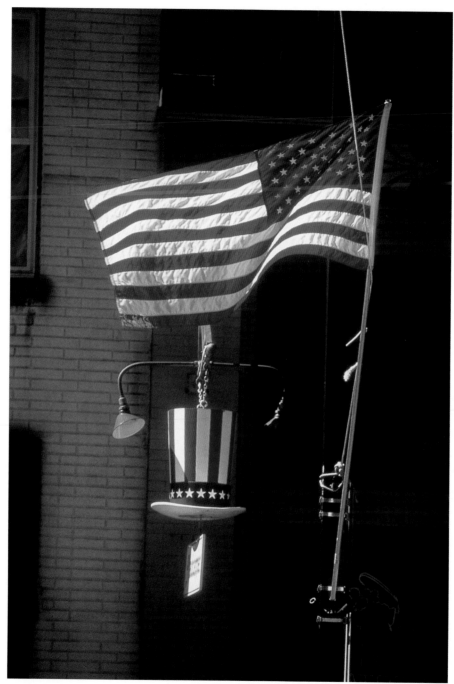

Stillwater, MN

Better a thousand times go down fighting
than dip your colors to dishonorable compromise.

President Woodrow Wilson

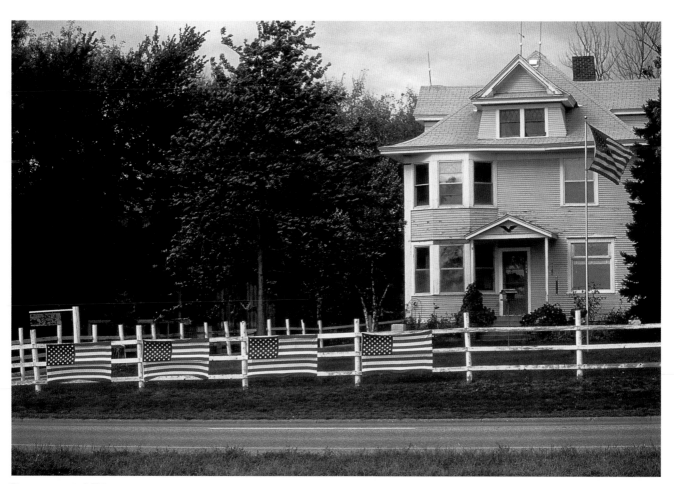

Rosemount, MN

Our country is more resolved,
more united,
and guided by a greater sense of purpose
than at any time during our lifetimes.

President George W. Bush

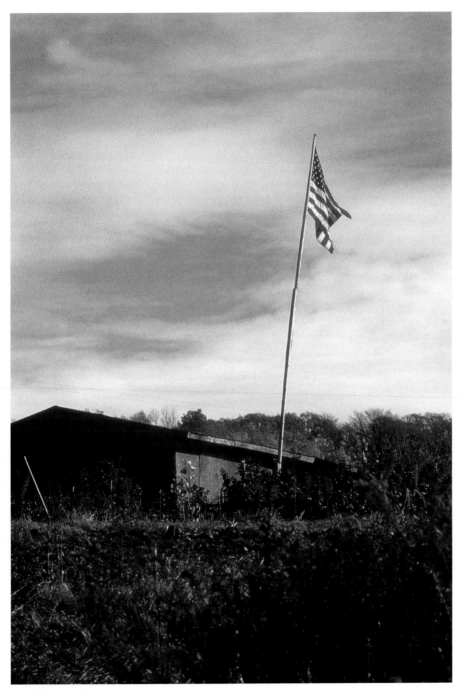

Red Wing, MN

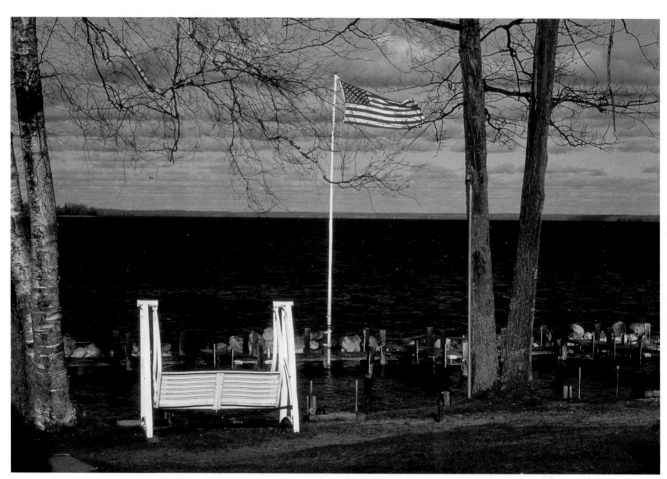

Leech Lake, MN

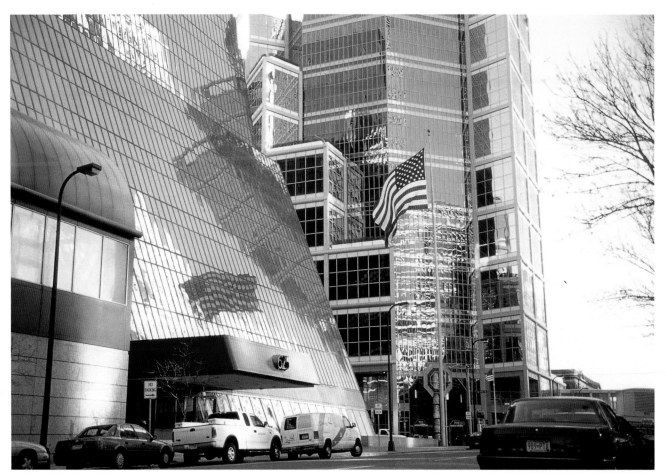

Minneapolis, MN

With malice toward none; with charity for all;
with firmness in the right, as God gives us to see the right,
let us strive on to finish the work we are in;
to bind up the nation's wounds;
to care for him who shall have borne the battle,
and for his widow, and for his orphan.
To do all which may achieve and cherish a just and lasting peace,
among ourselves, and with all nations.

President Abraham Lincoln

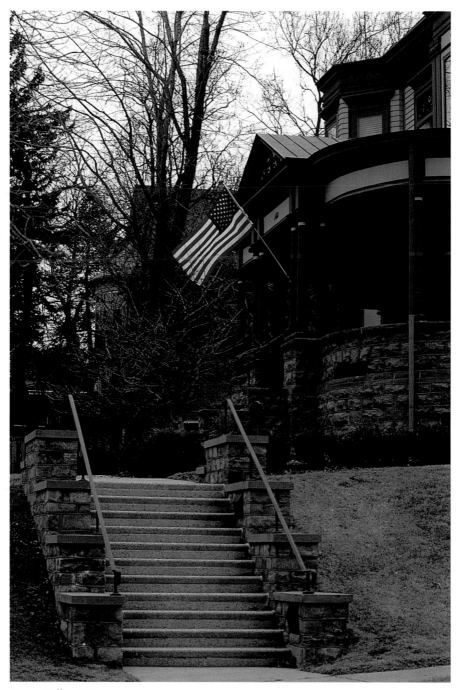

Sioux Falls, SD

Unity… Resolve… Freedom… These are the hallmarks of the American spirit.

President George W. Bush

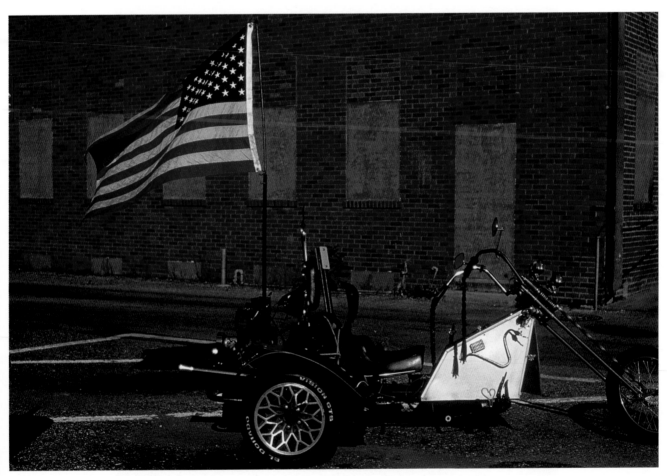

Alexandria, MN

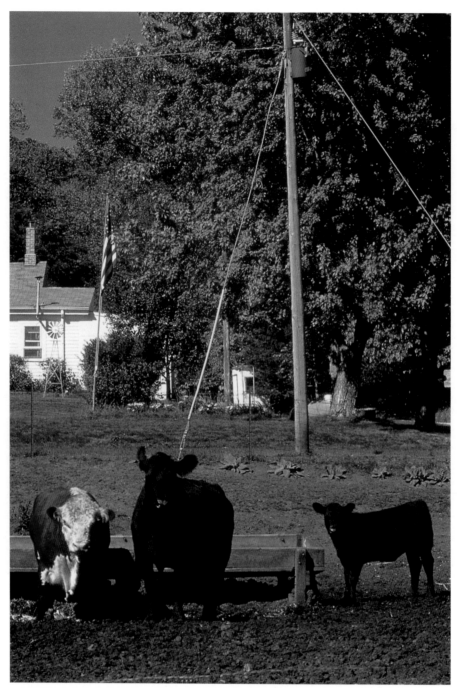

Henderson, MN

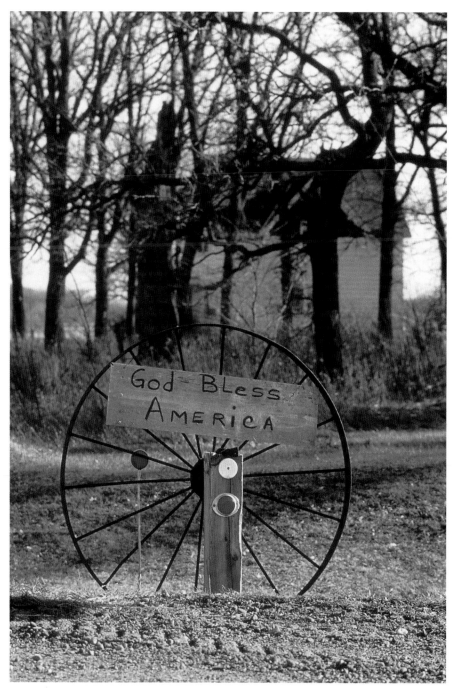

North Branch, MN

History is a ribbon, always unfurling; history is a journey. And as we continue our journey, we think of those who traveled before us. We stand together again at the steps of this symbol of our democracy. Now we hear again the echoes of our past: a general falls to his knees in the hard snow of Valley Forge; a lonely President paces the darkened hall, and ponders his struggle to preserve the Union; the men of the Alamo call out encouragement to each other; a settler pushes west and sings a song, and the song echoes out forever and fills the unknowing air. It is the American sound. It is hopeful, big-hearted, idealistic, daring, decent, and fair. That's our heritage; that is our song. We sing it still. For all our problems, our differences, we are together as of old, as we raise our voices to the God who is the Author of this most tender sound—sound in unity, affection, and love—one people under God, dedicated to the dream of freedom that He has placed in the human heart, called upon now to pass that dream on to a waiting and hopeful world. God bless you and may God bless America.

President Ronald Reagan

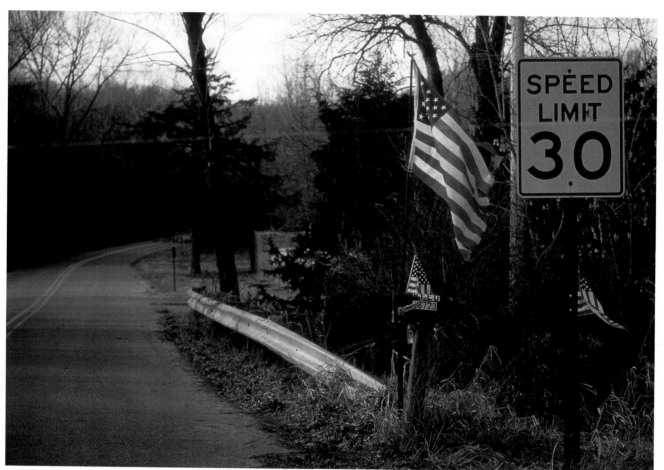

Copas, MN

Our Fathers

Our fathers were high-minded men,
who firmly kept the faith,
To freedom and to conscience true
in danger and in death.
Nor should their deeds be e'er forgot,
for noble men were they,
Who struggled hard for sacred rights,
and bravely won the day.

And such as our forefathers were, may we,
their children, be,
And in our hearts their spirits live,
that baffled tyranny.
Then we'll uphold the cause of right,
the cause of mercy too;
To toil or suffer for the truth
is the noblest thing to do.

Author Unknown

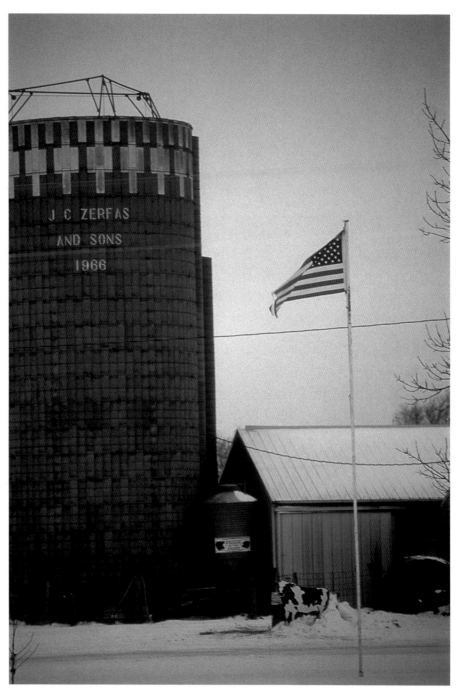

Watertown, SD

I Am Old Glory

They have prayed that they and their fellow citizens might continue to enjoy the life, liberty and pursuit of happiness, which have been granted to every American as the heritage of free men.

So long as men love liberty more than life itself; so long as they treasure the priceless privileges bought with the blood of our forefathers; so long as the principles of truth, justice, and charity for all remain deeply rooted in human hearts I shall continue to be the enduring banner of the United States of America.

Originally written by Master Sergeant Percy Webb, USMC

St. Peter, MN

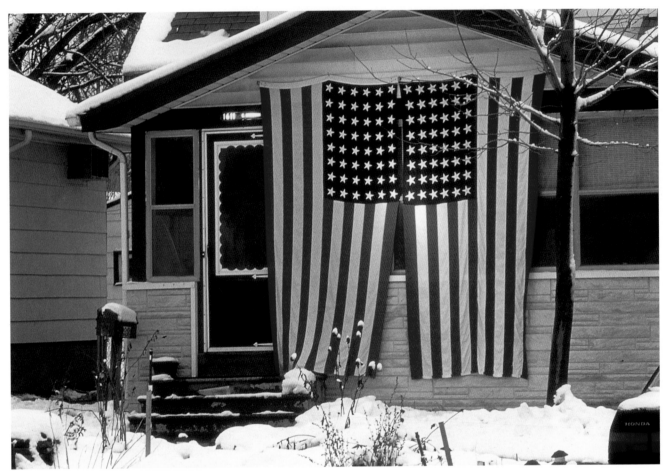

Minneapolis, MN

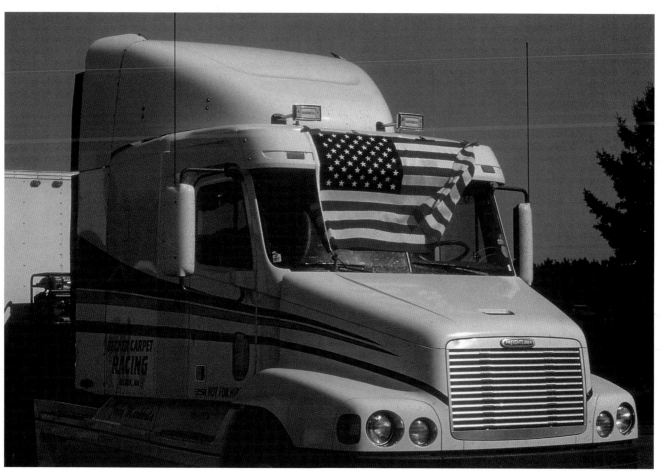

Becker, MN

The Flag of Our Country

There is the national flag. He must be cold indeed who can look upon its folds, rippling in the breeze, without pride of country. If he be in a foreign land, that flag is companionship and country itself, with all its endearments.

Charles Sumner

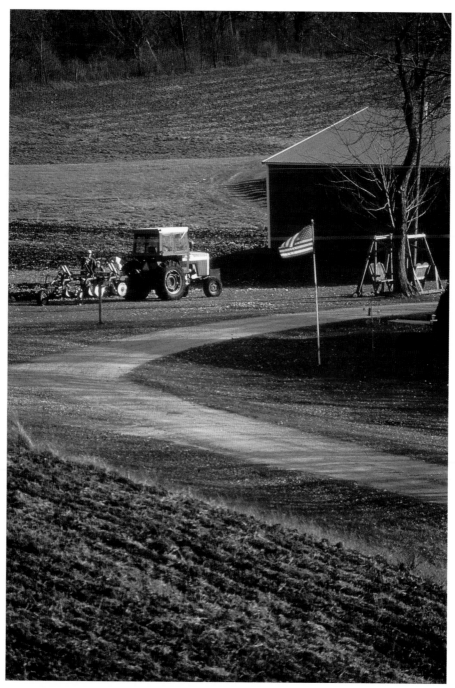

East of New Prague, MN on Hwy. 19

With Freedom's soil beneath our feet,
And Freedom's banner streaming o'er us...

Fitz-Greene Halleck

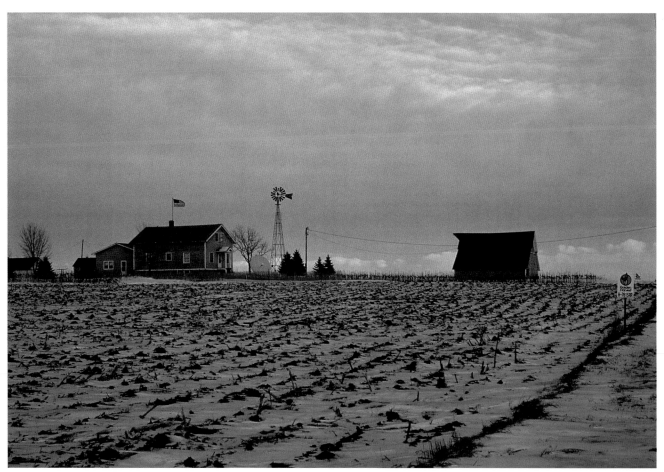

Northern IA on Hwy. 9

O Flag of Our Union

O flag of our Union,
To you we'll be true,
To your red and white stripes,
And your stars on the blue;
The emblem of freedom,
The symbol of right,
We children salute you,
 O flag fair and bright!

taught in classrooms

nearly one hundred years ago

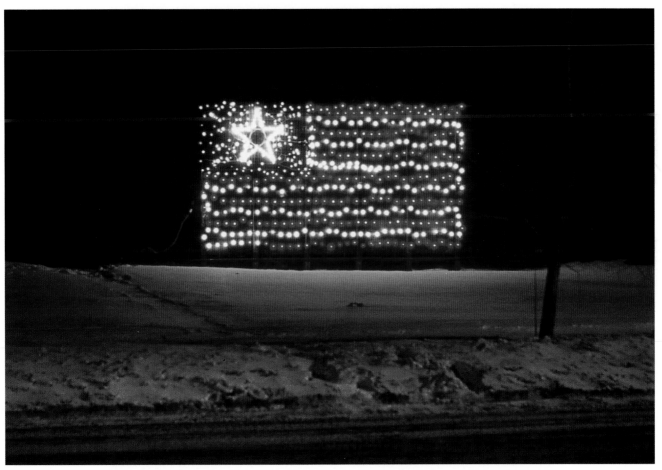

Wadena, MN

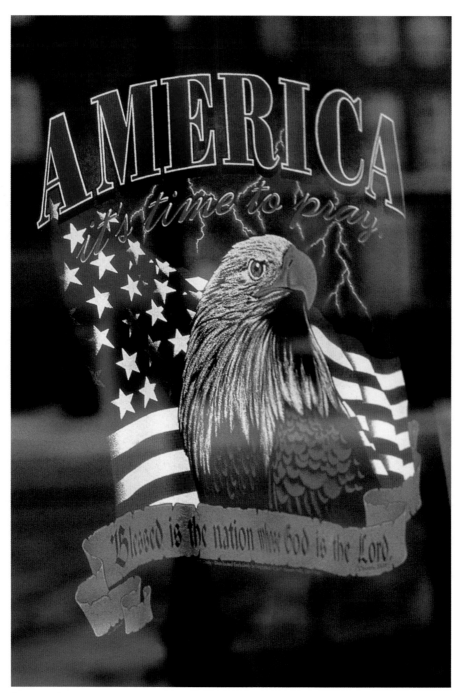

Spirit Lake, IA

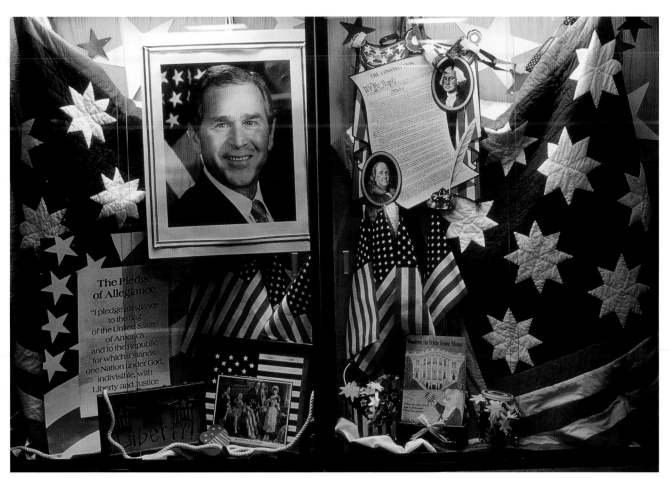

Menomonie, WI

I have always been inspired by America and its heroes—the cowboy, the soldier, and now the firefighters, police officers and rescue workers. There is one common thread in every hero. They are ordinary Americans, they come from nowhere, make their mark, get knocked down, and rise up again.

Ralph Lauren

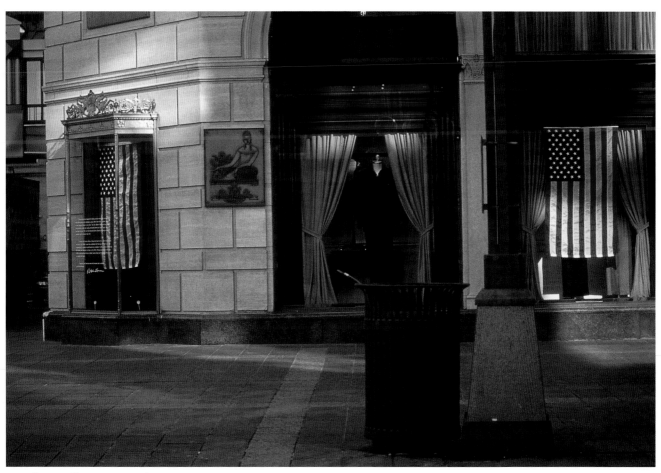

Nicollet Mall, Minneapolis, MN

The willingness with which our young people are likely to serve in any war, no matter how justified, will be directly proportional to how they perceive the veterans of earlier wars were treated and appreciated by their nation.

President George Washington

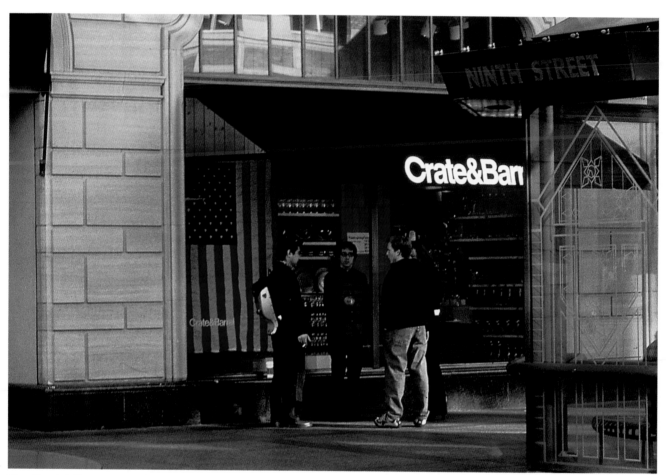

Nicollet Mall, Minneapolis, MN

In order for the tree of liberty to survive
it must be watered with the blood of its patriots of each generation.

President Thomas Jefferson

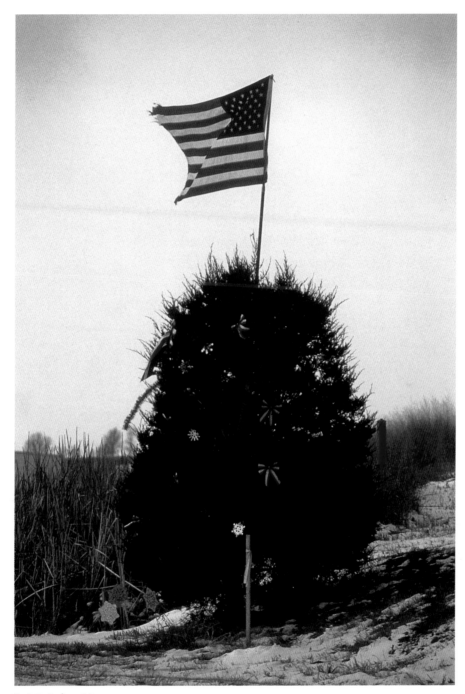

Spirit Lake, IA

Memorial Day—The Price They Paid

Our servicemen have lived and died,
 Many are no more alive;
Yet we honor them today
 With brightly-colored swaying flags.
The flowers open their bright faces
 And gleam o'er graves' dewy spaces.
We honor them on this day
 And think of the price they paid.
All gave some, some gave all.
 Wounds and life are not small.
Our hearts are filled with gratitude,
 That in the fight they stood true.

Joshua Aaron Peterson

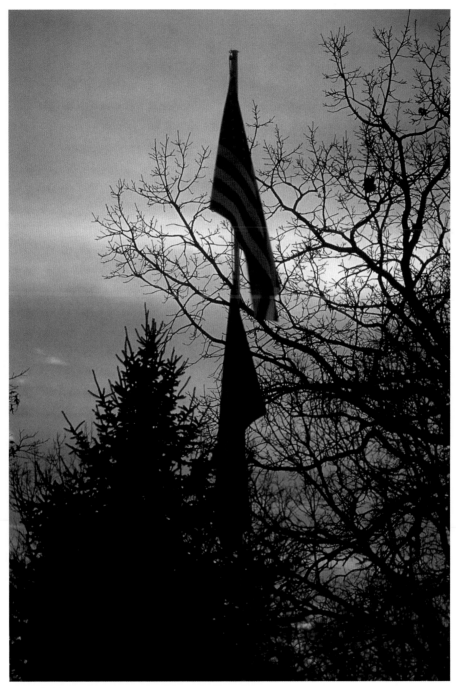

Rice, MN

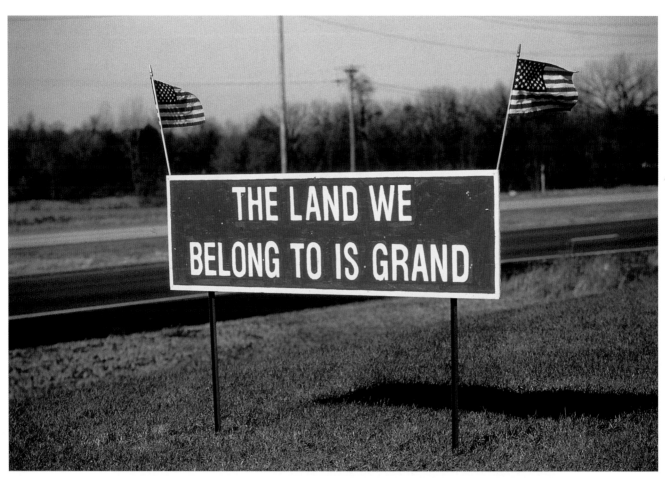

Jordan, MN

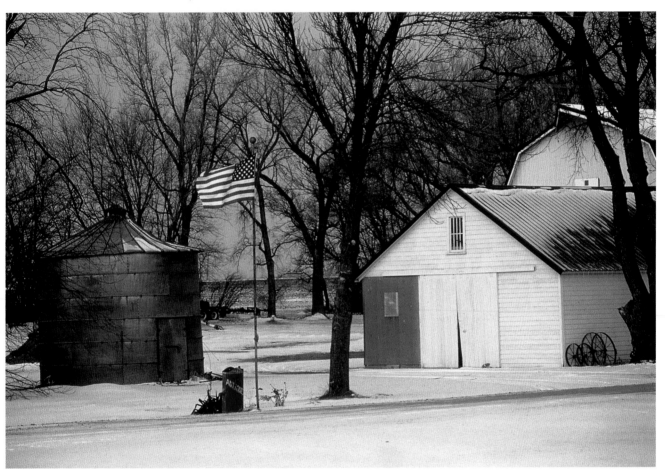

Flandreau, SD

You're a grand old flag,
You're a high-flyin' flag,
And forever in peace may you wave.
You're the emblem of
The land I love,
The home of the free and the brave.

George M. Cohan

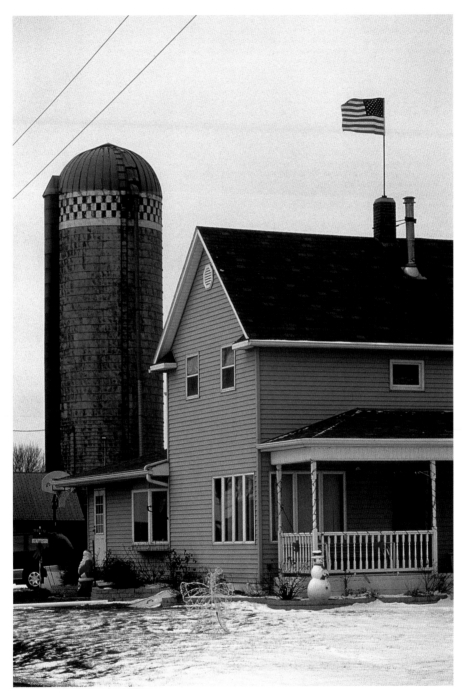

Northwestern IA, on Hwy. 9

The spirit of liberty is indeed a bold and fearless spirit.

Daniel Webster

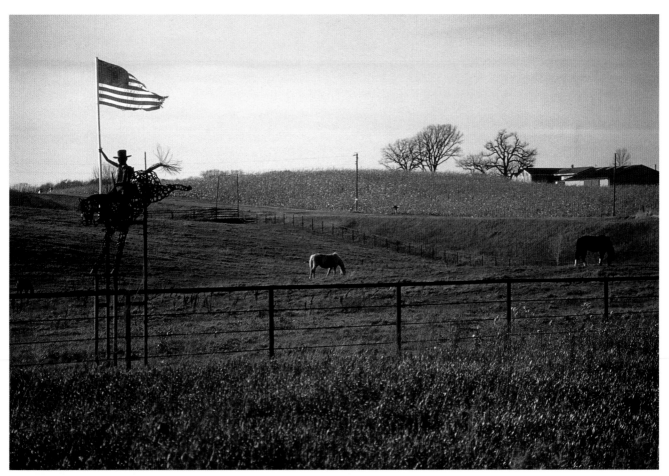

Along Interstate 35 in MN

Home is where you hang your heart.

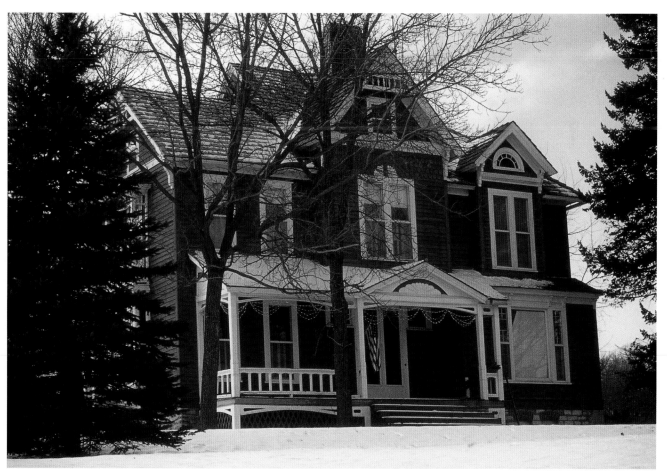

Esterville, IA

A house is made of brick and stone,
But a home is made of love alone.

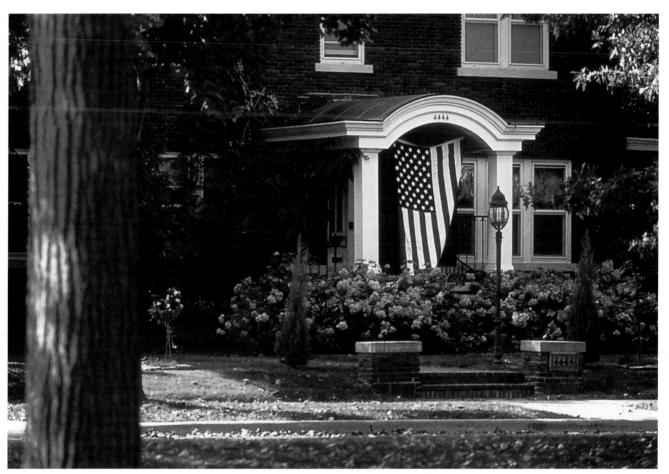

Minneapolis, MN

Trust

Build a little fence of trust
 Around today;
Fill each space with loving work
 And therein stay;
Look not through the sheltering bars
 Upon tomorrow,
God will help thee bear what comes,
 Of joy or sorrow.

Mary Frances Butts

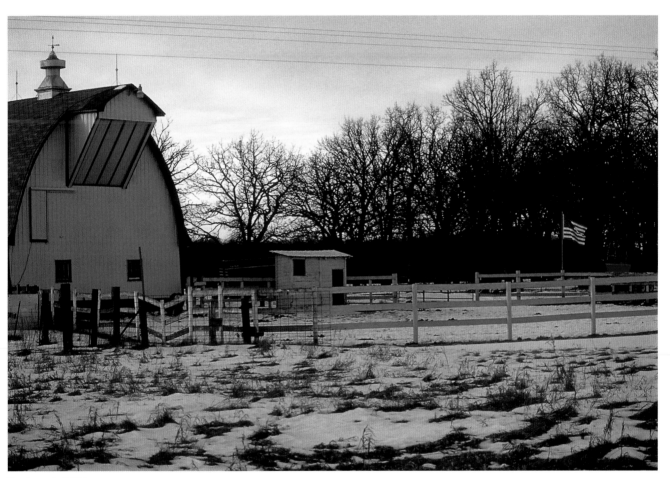

Brainerd, MN

Like our founding fathers who fought and died for freedom...
the cluster of arrows to defend our freedom
and the olive branch of peace
have now been handed to us.
We will hold them firmly in our hands,
honor their memory,
and lift them up toward heaven to light the world.

New York City Mayor Rudy Guiliani

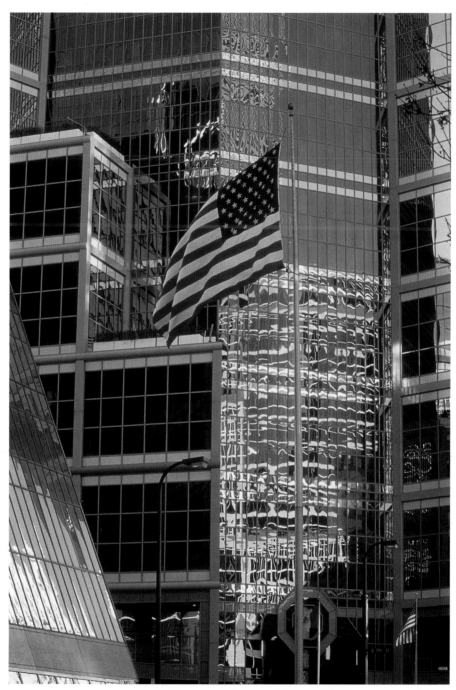

Minneapolis, MN

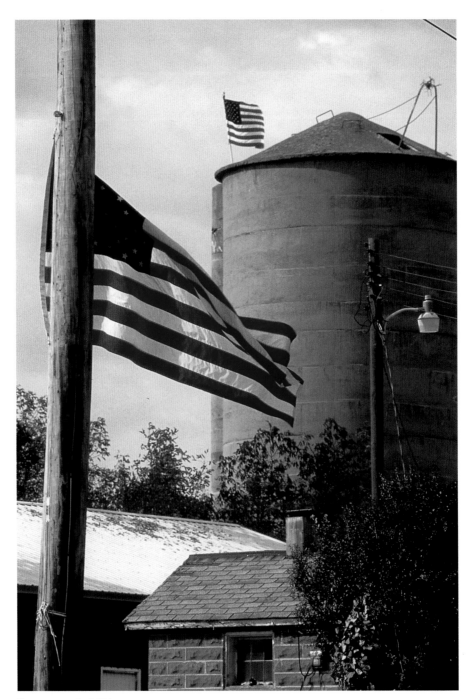

Rosemount, MN

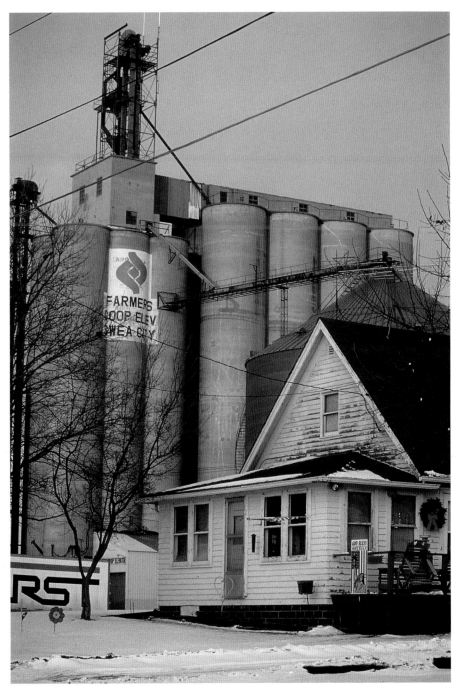

Swea City, IA

When my eyes shall be turned to behold for the last time the sun in heaven,... Let their last feeble and lingering glance... behold the glorious ensign of the republic, now known and honored throughout the earth, still full high advanced,... not a stripe erased or polluted, not a single star obscured... but everywhere, spread all over in characters of living light, blazing on all its ample folds, as they float over the sea and over the land,... that other sentiment, dear to every true American heart—Liberty and Union, now and forever, one and inseparable!

Daniel Webster

Volga, SD

We must all hang together, or, most assuredly, we shall all hang separately.

Benjamin Franklin, remark to John Hancock
at the signing of the Declaration of Independence

Oak Park Heights, MN

Castle Rock, MN

Red Wing, MN

Flag of Our Country

Who, as he sees it, can think of a state merely? Whose eyes, once fastened upon its radiant trophies, can fail to recognize the image of the whole nation? It has been called a "floating piece of poetry," and yet I know not if it has an intrinsic beauty beyond other ensigns. Its highest beauty is in what it symbolizes. It is because it represents all, that all gaze at it with delight and reverence.

Charles Sumner

St. Peter, MN

North of Pequot Lakes, MN

On Leech Lake in MN

The true test of civilization is, not the census, nor the size of cities, nor the crops—no, but the kind of man the country turns out.

Ralph Waldo Emerson

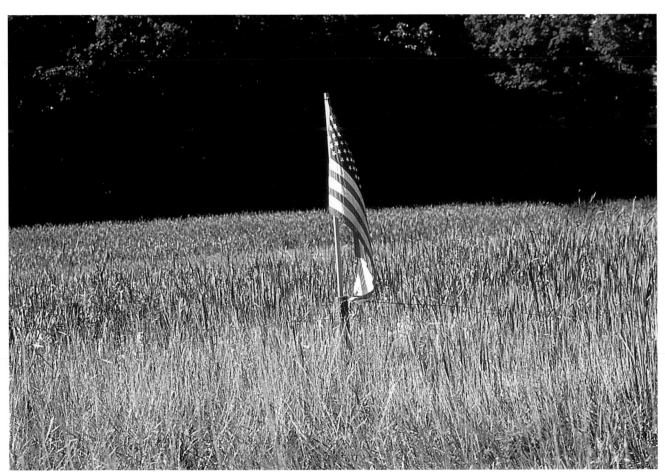

North of Sandstone, MN on Interstate 35

All any nation can give to each succeeding generation
is the possibility of freedom....
It is my prayer that our people will always remember:
freedom is never free.

General John A. Wickham, Jr.

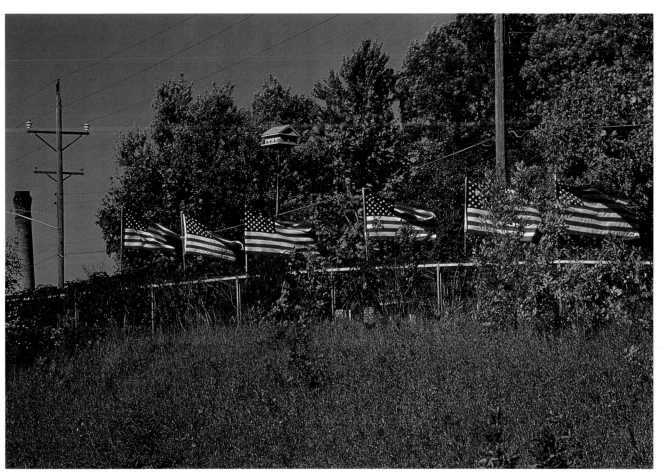

Freeport, MN

Our flag is our national ensign, pure and simple,
behold it!
Listen to it!
Every star has a tongue, every stripe is articulate.

Robert C. Winthrop

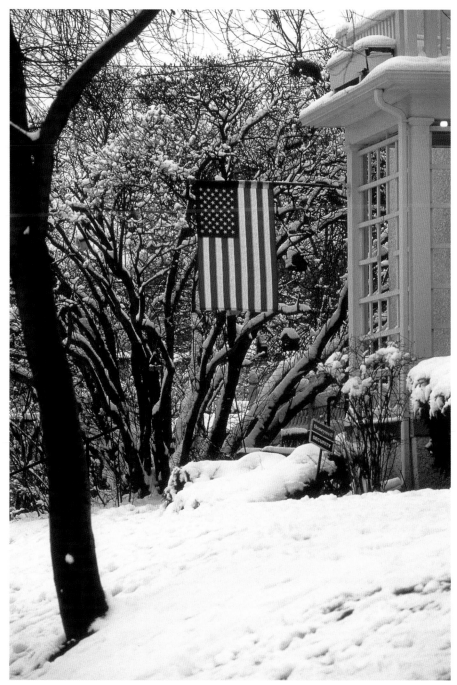

Minneapolis, MN

It is the soldier, not the reporter who has given us the freedom of press.

It is the soldier, not the poet who has given us the freedom of speech.

It is the soldier, not the campus organizer who gives us the freedom to demonstrate.

It is the soldier who salutes the flag, who serves beneath the flag, and whose coffin is draped by the flag, who allows the protester to burn the flag.

Dennis Edward O'Brien

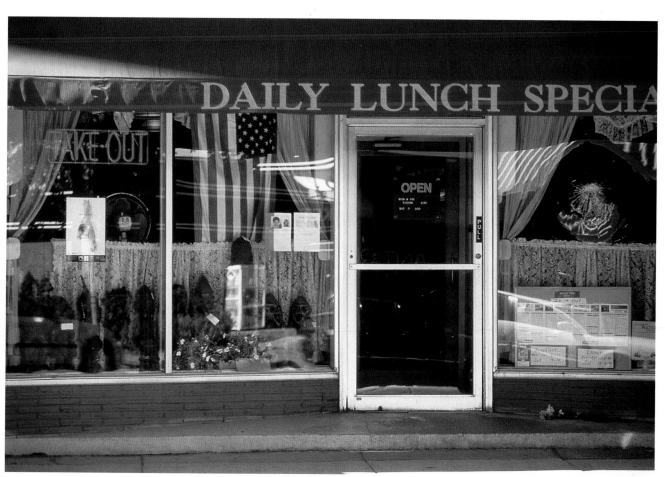

Stillwater, MN

A person gets from a symbol
the meaning he puts into it.

The United States Supreme Court

Stillwater, MN

I've never had more faith in America
than I have now.

President George W. Bush

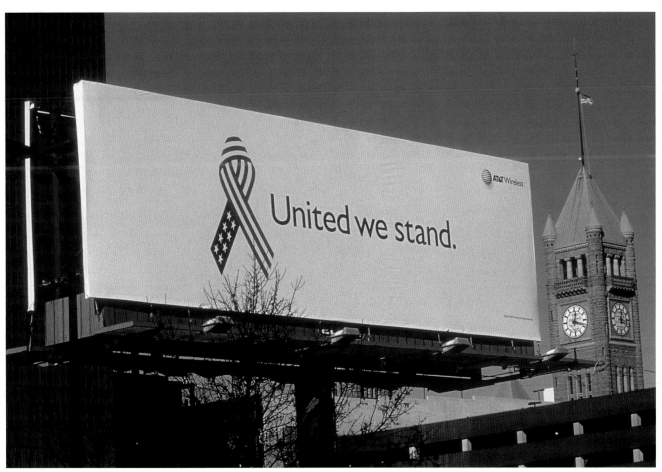

Minneapolis, MN

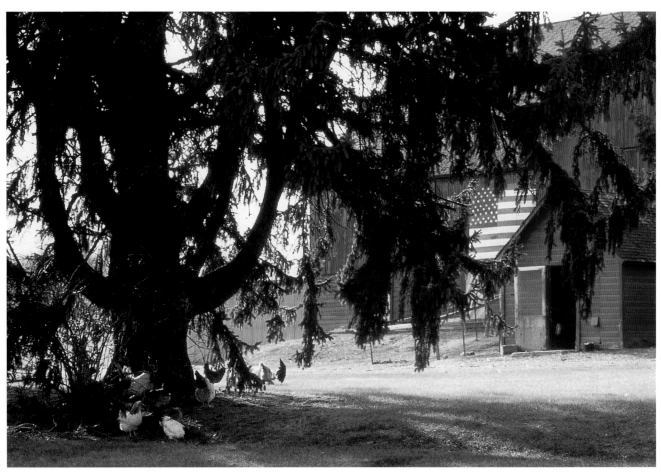

Scandia, MN

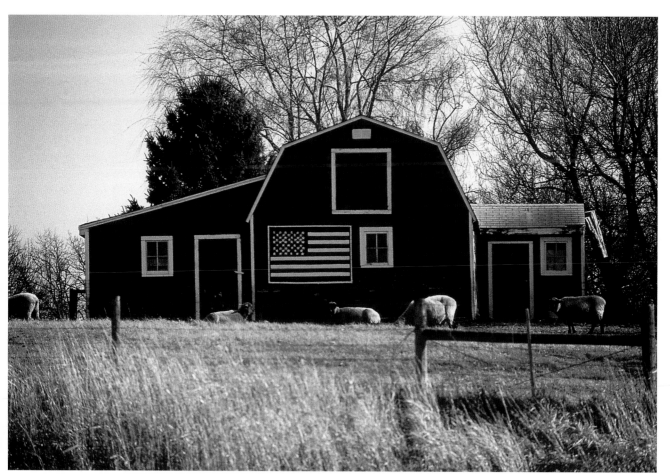

Albert Lea, MN

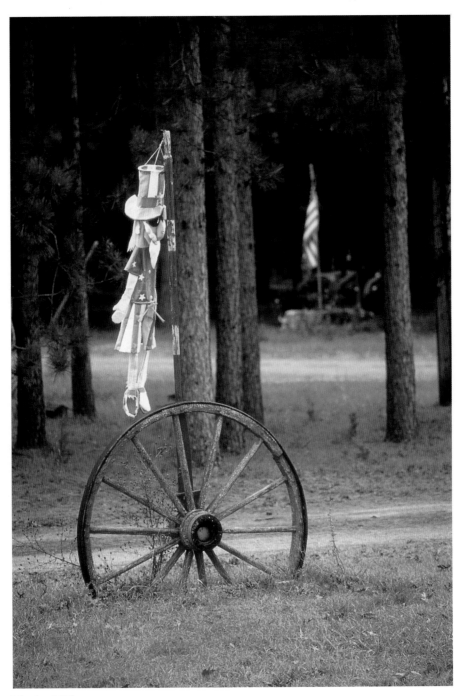

Nevis, MN

Royalton, MN

South of Jacobson, MN

Remer, MN

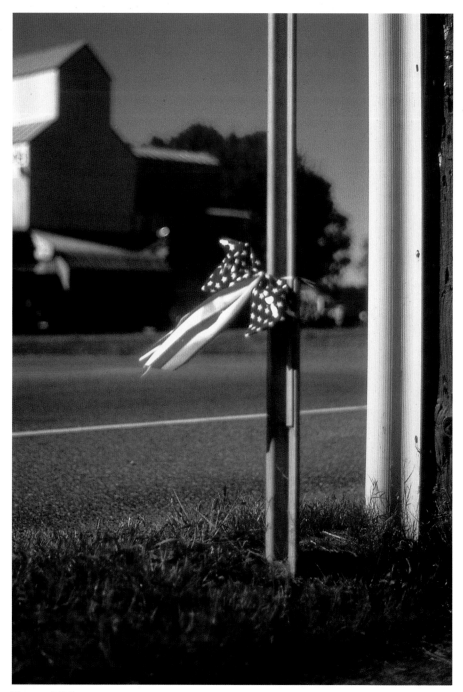

Hugo, MN

THE DECLARATION OF INDEPENDENCE

A Transcription

National Archives and Records Administration

IN CONGRESS, July 4, 1776.

The unanimous Declaration of the thirteen united States of America,

When in the Course of human events, it becomes necessary for one people to dissolve the political bands which have connected them with another, and to assume among the powers of the earth, the separate and equal station to which the Laws of Nature and of Nature's God entitle them, a decent respect to the opinions of mankind requires that they should declare the causes which impel them to the separation.

We hold these truths to be self-evident, that all men are created equal, that they are endowed by their Creator with certain unalienable Rights, that among these are Life, Liberty and the pursuit of Happiness.—That to secure these rights, Governments are instituted among Men, deriving their just powers from the consent of the governed,—That whenever any Form of Government becomes destructive of these ends, it is the Right of the People to alter or to abolish it, and to institute new Government, laying its foundation on such principles and organizing its powers in such form, as to them shall seem most likely to effect their Safety and Happiness. Prudence, indeed, will dictate that Governments long established should not be changed for light and transient causes; and accordingly all experience hath shewn, that mankind are more disposed to suffer, while evils are sufferable, , than to right themselves by abolishing the forms to which they are accustomed. But when a long train of abuses and usurpations, pursuing invariably the same Object evinces a design to reduce them under absolute Despotism, it is their right, it is their duty, to throw off such Government, and to provide new Guards for their future security.—Such has been the patient sufferance of these Colonies; and such is now the necessity which constrains them to alter their former Systems of Government. The history of the present King of Great Britain is a history of repeated injuries and usurpations, all having in direct object the establishment of an absolute Tyranny over these States. To prove this, let Facts be submitted to a candid world.

He has refused his Assent to Laws, the most wholesome and necessary for the public good.

He has forbidden his Governors to pass Laws of immediate and pressing importance, unless suspended in their operation till his Assent should be obtained; and when so suspended, he has utterly neglected to attend to them.

He has refused to pass other Laws for the accommodation of large districts of people, unless those people would relinquish the right of Representation in the Legislature, a right inestimable to them and formidable to tyrants only.

He has called together legislative bodies at places unusual, uncomfortable, and distant from the depository of their public Records, for the sole purpose of fatiguing them into compliance with his measures.

He has dissolved Representative Houses repeatedly, for opposing with manly firmness his invasions on the rights of the people.

He has refused for a long time, after such dissolutions, to cause others to be elected; whereby the Legislative powers, incapable of Annihilation, have returned to the People at large for their exercise; the State remaining in the mean time exposed to all the dangers of invasion from without, and convulsions within.

He has endeavoured to prevent the population of these States; for the purpose obstructing the Laws for Naturalization of Foreigner; refusing to pass others to encourage their migrations hither, and raising the conditions of new Appropriations of Lands.

He has obstructed the Administration of Justice, by refusing his Assent to Laws for establishing Judiciary powers.

He has made Judges dependent on his Will alone, for the tenure of their offices, and the amount and payment of their salaries.

He has erected a multitude of New Offices, and sent hither swarms of Officers to harrass our people, and eat out their substance.

He has kept among us, in times of peace, Standing Armies without the Consent of our legislatures.

He has affected to render the Military independent of and superior to the Civil power.

He has combined with others to subject us to a jurisdiction foreign to our constitution, and unacknowledged by our laws; giving his Assent to their Acts of pretended Legislation:

For Quartering large bodies of armed troops among us:

For protecting them, by a mock Trial, from punishment for any Murders which they should commit on the Inhabitants of these States:

For cutting off our Trade with all parts of the world:

For imposing Taxes on us without our Consent:

For depriving us in many cases, of the benefits of Trial by Jury:

For transporting us beyond Seas to be tried for pretended offences

For abolishing the free System of English Laws in a neighbouring Province, establishing therein an Arbitrary government, and enlarging its Boundaries so as to render it at once an example and fit instrument for introducing the same absolute rule into these Colonies:

For taking away our Charters, abolishing our most valuable Laws, and altering fundamentally the Forms of our Governments:

For suspending our own Legislatures, and declaring themselves invested with power to legislate for us in all cases whatsoever.

He has abdicated Government here, by declaring us out of his Protection and waging War against us.

He has plundered our seas, ravaged our Coasts, burnt our towns, and destroyed the lives of our people.

He is at this time transporting large Armies of foreign Mercenaries to compleat the works of death, desolation and tyranny, already begun with circumstances of Cruelty & perfidy scarcely paralleled in the most barbarous ages, and totally unworthy the Head of a civilized nation.

He has constrained our fellow Citizens taken Captive on the high Seas to bear Arms against their Country, to become the executioners of their friends and Brethren, or to fall themselves by their Hands.

He has excited domestic insurrections amongst us, and has endeavoured to bring on the inhabitants of our frontiers, the merciless Indian Savages, whose known rule of warfare, is an undistinguished destruction of all ages, sexes and conditions.

In every stage of these Oppressions We have Petitioned for Redress in the most humble terms: Our repeated Petitions have been answered only by repeated injury. A Prince whose character is thus marked by every act which may define a Tyrant, is unfit to be the ruler of a free people.

Nor have We been wanting in attentions to our Brittish brethren. We have warned them from time to time of attempts by their legislature to extend an unwarrantable jurisdiction over us. We have reminded them of the circumstances of our emigration and settlement here. We have appealed to their native justice and magnanimity, and we have conjured them by the ties of our common kindred to disavow these usurpations, which would inevitably interrupt our connections and correspondence. They too have been deaf to the voice of justice and of consanguinity. We must, therefore, acquiesce in the necessity, which denounces our Separation, and hold them, as we hold the rest of mankind, Enemies in War, in Peace Friends.

We, therefore, the Representatives of the united States of America, in General Congress, Assembled, appealing to the Supreme Judge of the world for the rectitude of our intentions, do, in the Name, and by Authority of the good People of these Colonies, solemnly publish and declare, That these United Colonies are, and of Right ought to be Free and Independent States; that they are Absolved from all Allegiance to the British Crown, and that all political connection between them and the State of Great Britain, is and ought to be totally dissolved; and that as Free and Independent States, they have full Power to levy War, conclude Peace, contract Alliances, establish Commerce, and to do all other Acts and Things which Independent States may of right do. And for the support of this Declaration, with a firm reliance on the protection of divine Providence, we mutually pledge to each other our Lives, our Fortunes and our sacred Honor.

The 56 signatures on the Declaration appear in the positions indicated:

[Column 1]

GEORGIA:
Button Gwinnett
Lyman Hall
George Walton

[Column 2]

NORTH CAROLINA:
William Hooper
Joseph Hewes
John Penn

SOUTH CAROLINA:
Edward Rutledge
Thomas Heyward, Jr.
Thomas Lynch, Jr.
Arthus Middleton

[Column 3]

MASSACHUSETTS:
John Hancock

MARYLAND:
Samuel Chase
William Paca
Thomas Stone
Charles Carroll of
 Carrollton

VIRGINIA:
George Wythe
Richard Henry Lee
Thomas Jefferson
Benjamin Harrison
Thomas Nelson, Jr.
Francis Lightfoot Lee
Carter Braxton

[Column 4]

PENNSYLVANIA:
Robert Morris
Benjamin Rush
Benjamin Franklin
John Morton
George Clymer
James Smith
George Taylor
James Wilson
George Ross

DELAWARE:
Caesar Rodney
George Read
Thomas McKean

[Column 5]

NEW YORK:
William Floyd
Philip Livingston
Francis Lewis
Lewis Morris

NEW JERSEY:
Richard Stockton
John Witherspoon
Francis Hopkinson
John Hart
Abraham Clark

[Column 6]

NEW HAMPSHIRE:
Josiah Bartlett
William Whipple

MASSACHUSETTS:
Samuel Adams
John Adams
Robert Treat Paine
Elbridge Gerry

RHODE ISLAND:
Stephen Hopkins
William Ellery

CONNECTICUT:
Roger Sherman
Samuel Huntington
William Williams
Oliver Wolcott

NEW HAMPSHIRE:
Matthew Thornton

THE CONSTITUTION OF THE UNITED STATES

Preamble

We the People of the United States, in Order to form a more perfect Union, establish Justice, insure domestic Tranquility, provide for the common defence, promote the general Welfare, and secure the Blessings of Liberty to ourselves and our Posterity, do ordain and establish this Constitution for the United States of America.

ARTICLE I. - THE LEGISLATIVE BRANCH

SECTION 1 - THE LEGISLATURE
All legislative Powers herein granted shall be vested in a Congress of the United States, which shall consist of a Senate and House of Representatives.

SECTION 2 - THE HOUSE
The House of Representatives shall be composed of Members chosen every second Year by the People of the several States, and the Electors in each State shall have the Qualifications requisite for Electors of the most numerous Branch of the State Legislature.

No Person shall be a Representative who shall not have attained to the Age of twenty five Years, and been seven Years a Citizen of the United States, and who shall not, when elected, be an Inhabitant of that State in which he shall be chosen.

(Representatives and direct Taxes shall be apportioned among the several States which may be included within this Union, according to their respective Numbers, which shall be determined by adding to the whole Number of free Persons, including those bound to Service for a Term of Years, and excluding Indians not taxed, three fifths of all other Persons.) (The previous sentence in parentheses was superseded by Amendment XIV, section 2.) The actual Enumeration shall be made within three Years after the first Meeting of the Congress of the United States, and within every subsequent Term of ten Years, in such Manner as they shall by Law direct. The Number of Representatives shall not exceed one for every thirty Thousand, but each State shall have at Least one Representative; and until such enumeration shall be made, the State of New Hampshire shall be entitled to chuse three, Massachusetts eight, Rhode Island and Providence Plantations one, Connecticut five, New York six, New Jersey four, Pennsylvania eight, Delaware one, Maryland six, Virginia ten, North Carolina five, South Carolina five and Georgia three.

When vacancies happen in the Representation from any State, the Executive Authority thereof shall issue Writs of Election to fill such Vacancies.

The House of Representatives shall chuse their Speaker and other Officers; and shall have the sole Power of Impeachment.

SECTION 3 - THE SENATE
The Senate of the United States shall be composed of two Senators from each State, (chosen by the Legislature thereof,) (The preceding words in parentheses superseded by Amendment XVII, section 1.) for six Years; and each Senator shall have one Vote.

Immediately after they shall be assembled in Consequence of the first Election, they shall be divided as equally as may be into three Classes. The Seats of the Senators of the first Class shall be vacated at the Expiration of the second Year, of the second Class at the Expiration of the fourth Year, and of the third Class at the Expiration of the sixth Year, so that one third may be chosen every second Year; (and if Vacancies happen by Resignation, or otherwise, during the Recess of the Legislature of any State, the Executive thereof may make temporary Appointments until the next Meeting of the Legislature, which shall then fill such Vacancies.) (The preceding words in parentheses were superseded by Amendment XVII, section 2.)

No person shall be a Senator who shall not have attained to the Age of thirty Years, and been nine Years a Citizen of the United States, and who shall not, when elected, be an Inhabitant of that State for which he shall be chosen.

The Vice President of the United States shall be President of the Senate, but shall have no Vote, unless they be equally divided.

The Senate shall chuse their other Officers, and also a President pro tempore, in the absence of the Vice President, or when he shall exercise the Office of President of the United States.

The Senate shall have the sole Power to try all Impeachments. When sitting for that Purpose, they shall be on Oath or Affirmation. When the President of the United States is tried, the Chief Justice shall preside: And no Person shall be convicted without the Concurrence of two thirds of the Members present.

Judgment in Cases of Impeachment shall not extend further than to removal from Office, and disqualification to hold and enjoy any Office of honor, Trust or Profit under the United States: but the Party convicted shall nevertheless be liable and subject to

Indictment, Trial, Judgment and Punishment, according to Law.

SECTION 4 - ELECTIONS, MEETINGS
The Times, Places and Manner of holding Elections for Senators and Representatives, shall be prescribed in each State by the Legislature thereof; but the Congress may at any time by Law make or alter such Regulations, except as to the Place of Chusing Senators.

The Congress shall assemble at least once in every Year, and such Meeting shall (be on the first Monday in December,) (The preceding words in parentheses were superseded by Amendment XX, section 2.) unless they shall by Law appoint a different Day.

SECTION 5 - MEMBERSHIP, RULES, JOURNALS, ADJOURNMENT
Each House shall be the Judge of the Elections, Returns and Qualifications of its own Members, and a Majority of each shall constitute a Quorum to do Business; but a smaller number may adjourn from day to day, and may be authorized to compel the Attendance of absent Members, in such Manner, and under such Penalties as each House may provide.

Each House may determine the Rules of its Proceedings, punish its Members for disorderly Behavior, and, with the Concurrence of two-thirds, expel a Member.

Each House shall keep a Journal of its Proceedings, and from time to time publish the same, excepting such Parts as may in their Judgment require Secrecy; and the Yeas and Nays of the Members of either House on any question shall, at the Desire of one fifth of those Present, be entered on the Journal.

Neither House, during the Session of Congress, shall, without the Consent of the other, adjourn for more than three days, nor to any other Place than that in which the two Houses shall be sitting.

SECTION 6 - COMPENSATION
(The Senators and Representatives shall receive a Compensation for their Services, to be ascertained by Law, and paid out of the Treasury of the United States.) (The preceding words in parentheses were modified by Amendment XVII.) They shall in all Cases, except Treason, Felony and Breach of the Peace, be privileged from Arrest during their Attendance at the Session of their respective Houses, and in going to and returning from the same; and for any Speech or Debate in either House, they shall not be questioned in any other Place.

No Senator or Representative shall, during the Time for which he was elected, be appointed to any civil Office under the Authority of the United States which shall have been created, or the Emoluments whereof shall have been increased during such time; and no Person holding any Office under the United States, shall be a Member of either House during his Continuance in Office.

SECTION 7 - REVENUE BILLS, LEGISLATIVE PROCESS, PRESIDENTIAL VETO
All bills for raising Revenue shall originate in the House of Representatives; but the Senate may propose or concur with Amendments as on other Bills.

Every Bill which shall have passed the House of Representatives and the Senate, shall, before it become a Law, be presented to the President of the United States; If he approve he shall sign it, but if not he shall return it, with his Objections to that House in which it shall have originated, who shall enter the Objections at large on their Journal, and proceed to reconsider it. If after such Reconsideration two thirds of that House shall agree to pass the Bill, it shall be sent, together with the Objections, to the other House, by which it shall likewise be reconsidered, and if approved by two thirds of that House, it shall become a Law. But in all such Cases the Votes of both Houses shall be determined by Yeas and Nays, and the Names of the Persons voting for and against the Bill shall be entered on the Journal of each House respectively. If any Bill shall not be returned by the President within ten Days (Sundays excepted) after it shall have been presented to him, the Same shall be a Law, in like Manner as if he had signed it, unless the Congress by their Adjournment prevent its Return, in which Case it shall not be a Law.

Every Order, Resolution, or Vote to which the Concurrence of the Senate and House of Representatives may be necessary (except on a question of Adjournment) shall be presented to the President of the United States; and before the Same shall take Effect, shall be approved by him, or being disapproved by him, shall be repassed by two thirds of the Senate and House of Representatives, according to the Rules and Limitations prescribed in the Case of a Bill.

SECTION 8 - POWERS OF CONGRESS
The Congress shall have Power To lay and collect Taxes, Duties, Imposts and Excises, to pay the Debts and provide for the common Defence and general Welfare of the United States; but all Duties, Imposts and Excises shall be uniform throughout the United States;

To borrow money on the credit of the United States;

To regulate Commerce with foreign Nations, and among the several States, and with the Indian Tribes;

To establish an uniform Rule of Naturalization, and uniform Laws on the subject of Bankruptcies throughout the United States;

To coin Money, regulate the Value thereof, and of foreign Coin, and fix the Standard of Weights and Measures;

To provide for the Punishment of counterfeiting the Securities and current Coin of the United States;

To establish Post Offices and Post Roads;

To promote the Progress of Science and useful Arts, by securing for limited Times to Authors and Inventors the exclusive Right to their respective Writings and Discoveries;

To constitute Tribunals inferior to the supreme Court;

To define and punish Piracies and Felonies committed on the high Seas, and Offenses against the Law of Nations;

To declare War, grant Letters of Marque and Reprisal, and make Rules concerning Captures on Land and Water;

To raise and support Armies, but no Appropriation of Money to that Use shall be for a longer Term than two Years;

To provide and maintain a Navy;

To make Rules for the Government and Regulation of the land and naval Forces;

To provide for calling forth the Militia to execute the Laws of the Union, suppress Insurrections and repel Invasions;

To provide for organizing, arming, and disciplining the Militia, and for governing such Part of them as may be employed in the Service of the United States, reserving to the States respectively, the Appointment of the Officers, and the Authority of training the Militia according to the discipline prescribed by Congress;

To exercise exclusive Legislation in all Cases whatsoever, over such District (not exceeding ten Miles square) as may, by Cession of particular States, and the acceptance of Congress, become the Seat of the Government of the United States, and to exercise like Authority over all Places purchased by the Consent of the Legislature of the State in which the Same shall be, for the Erection of Forts, Magazines, Arsenals, dock-Yards, and other needful Buildings; And

To make all Laws which shall be necessary and proper for carrying into Execution the foregoing Powers, and all other Powers vested by this Constitution in the Government of the United States, or in any Department or Officer thereof.

SECTION 9 - LIMITS ON CONGRESS
The Migration or Importation of such Persons as any of the States now existing shall think proper to admit, shall not be prohibited by the Congress prior to the Year one thousand eight hundred and eight, but a tax or duty may be imposed on such Importation, not exceeding ten dollars for each Person.

The privilege of the Writ of Habeas Corpus shall not be suspended, unless when in Cases of Rebellion or Invasion the public Safety may require it.

No Bill of Attainder or ex post facto Law shall be passed.

(No capitation, or other direct, Tax shall be laid, unless in Proportion to the Census or Enumeration herein before directed to be taken.) (Section in parentheses modified by Amendment XVI.)

No Tax or Duty shall be laid on Articles exported from any State.

No Preference shall be given by any Regulation of Commerce or Revenue to the Ports of one State over those of another: nor shall Vessels bound to, or from, one State, be obliged to enter, clear, or pay Duties in another.

No Money shall be drawn from the Treasury, but in Consequence of Appropriations made by Law; and a regular Statement and Account of the Receipts and Expenditures of all public Money shall be published from time to time.

No Title of Nobility shall be granted by the United States: And no Person holding any Office of Profit or Trust under them, shall, without the Consent of the Congress, accept of any present, Emolument, Office, or Title, of any kind whatever, from any King, Prince or foreign State.

Section 10 - Powers prohibited of States

No State shall enter into any Treaty, Alliance, or Confederation; grant Letters of Marque and Reprisal; coin Money; emit Bills of Credit; make any Thing but gold and silver Coin a Tender in Payment of Debts; pass any Bill of Attainder, ex post facto Law, or Law impairing the Obligation of Contracts, or grant any Title of Nobility.

No State shall, without the Consent of the Congress, lay any Imposts or Duties on Imports or Exports, except what may be absolutely necessary for executing it's inspection Laws: and the net Produce of all Duties and Imposts, laid by any State on Imports or Exports, shall be for the Use of the Treasury of the United States; and all such Laws shall be subject to the Revision and Controul of the Congress.

No State shall, without the Consent of Congress, lay any duty of Tonnage, keep Troops, or Ships of War in time of Peace, enter into any Agreement or Compact with another State, or with a foreign Power, or engage in War, unless actually invaded, or in such imminent Danger as will not admit of delay.

ARTICLE II. - THE EXECUTIVE BRANCH

Section 1 - The President

The executive Power shall be vested in a President of the United States of America. He shall hold his Office during the Term of four Years, and, together with the Vice-President chosen for the same Term, be elected, as follows:

Each State shall appoint, in such Manner as the Legislature thereof may direct, a Number of Electors, equal to the whole Number of Senators and Representatives to which the State may be entitled in the Congress: but no Senator or Representative, or Person holding an Office of Trust or Profit under the United States, shall be appointed an Elector.

(The Electors shall meet in their respective States, and vote by Ballot for two persons, of whom one at least shall not lie an Inhabitant of the same State with themselves. And they shall make a List of all the Persons voted for, and of the Number of Votes for each; which List they shall sign and certify, and transmit sealed to the Seat of the Government of the United States, directed to the President of the Senate. The President of the Senate shall, in the Presence of the Senate and House of Representatives, open all the Certificates, and the Votes shall then be counted. The Person having the greatest Number of Votes shall be the President, if such Number be a Majority of the whole Number of Electors appointed; and if there be more than one who have such Majority, and have an equal Number of Votes, then the House of Representatives shall immediately chuse by Ballot one of them for President; and if no Person have a Majority, then from the five highest on the List the said House shall in like Manner chuse the President. But in chusing the President, the Votes shall be taken by States, the Representation from each State having one Vote; a quorum for this Purpose shall consist of a Member or Members from two- thirds of the States, and a Majority of all the States shall be necessary to a Choice. In every Case, after the Choice of the President, the Person having the greatest Number of Votes of the Electors shall be the Vice President. But if there should remain two or more who have equal Votes, the Senate shall chuse from them by Ballot the Vice-President.) (This clause in parentheses was superseded by Amendment XII.)

The Congress may determine the Time of chusing the Electors, and the Day on which they shall give their Votes; which Day shall be the same throughout the United States.

No person except a natural born Citizen, or a Citizen of the United States, at the time of the Adoption of this Constitution, shall be eligible to the Office of President; neither shall any Person be eligible to that Office who shall not have attained to the Age of thirty-five Years, and been fourteen Years a Resident within the United States.

(In Case of the Removal of the President from Office, or of his Death, Resignation, or Inability to discharge the Powers and Duties of the said Office, the same shall devolve on the Vice President, and the Congress may by Law provide for the Case of Removal, Death, Resignation or Inability, both of the President and Vice President, declaring what Officer shall then act as President, and such Officer shall act accordingly, until the Disability be removed, or a President shall be elected.) (This clause in parentheses has been modified by Amendments XX and XXV.)

The President shall, at stated Times, receive for his Services, a Compensation, which shall neither be increased nor diminished during the Period for which he shall have been elected, and he shall not receive within that Period any other Emolument from the United States, or any of them.

Before he enter on the Execution of his Office, he shall take the following Oath or Affirmation:

"I do solemnly swear (or affirm) that I will faithfully execute the Office of President of the United States, and will to the best of my Ability, preserve, protect and defend the Constitution of the United States."

SECTION 2 - CIVILIAN POWER OVER MILITARY, CABINET, PARDON POWER, APPOINTMENTS

The President shall be Commander in Chief of the Army and Navy of the United States, and of the Militia of the several States, when called into the actual Service of the United States; he may require the Opinion, in writing, of the principal Officer in each of the executive Departments, upon any subject relating to the Duties of their respective Offices, and he shall have Power to Grant Reprieves and Pardons for Offenses against the United States, except in Cases of Impeachment.

He shall have Power, by and with the Advice and Consent of the Senate, to make Treaties, provided two thirds of the Senators present concur; and he shall nominate, and by and with the Advice and Consent of the Senate, shall appoint Ambassadors, other public Ministers and Consuls, Judges of the supreme Court, and all other Officers of the United States, whose Appointments are not herein otherwise provided for, and which shall be established by Law: but the Congress may by Law vest the Appointment of such inferior Officers, as they think proper, in the President alone, in the Courts of Law, or in the Heads of Departments.

The President shall have Power to fill up all Vacancies that may happen during the Recess of the Senate, by granting Commissions which shall expire at the End of their next Session.

SECTION 3 - STATE OF THE UNION, CONVENING CONGRESS

He shall from time to time give to the Congress Information of the State of the Union, and recommend to their Consideration such Measures as he shall judge necessary and expedient; he may, on extraordinary Occasions, convene both Houses, or either of them, and in Case of Disagreement between them, with Respect to the Time of Adjournment, he may adjourn them to such Time as he shall think proper; he shall receive Ambassadors and other public Ministers; he shall take Care that the Laws be faithfully executed, and shall Commission all the Officers of the United States.

SECTION 4 - DISQUALIFICATION

The President, Vice President and all civil Officers of the United States, shall be removed from Office on Impeachment for, and Conviction of, Treason, Bribery, or other high Crimes and Misdemeanors.

ARTICLE III. - THE JUDICIAL BRANCH

SECTION 1 - JUDICIAL POWERS

The judicial Power of the United States, shall be vested in one supreme Court, and in such inferior Courts as the Congress may from time to time ordain and establish. The Judges, both of the supreme and inferior Courts, shall hold their Offices during good Behavior, and shall, at stated Times, receive for their Services a Compensation which shall not be diminished during their Continuance in Office.

SECTION 2 - TRIAL BY JURY, ORIGINAL JURISDICTION, JURY TRIALS

(The judicial Power shall extend to all Cases, in Law and Equity, arising under this Constitution, the Laws of the United States, and Treaties made, or which shall be made, under their Authority; to all Cases affecting Ambassadors, other public Ministers and Consuls; to all Cases of admiralty and maritime Jurisdiction; to Controversies to which the United States shall be a Party; to Controversies between two or more States; between a State and Citizens of another State; between Citizens of different States; between Citizens of the same State claiming Lands under Grants of different States, and between a State, or the Citizens thereof, and foreign States, Citizens or Subjects.) (This section in parentheses is modified by Amendment XI.)

In all Cases affecting Ambassadors, other public Ministers and Consuls, and those in which a State shall be Party, the supreme Court shall have original Jurisdiction. In all the other Cases before mentioned, the supreme Court shall have appellate Jurisdiction, both as to Law and Fact, with such Exceptions, and under such Regulations as the Congress shall make.

Trial of all Crimes, except in Cases of Impeachment, shall be by Jury; and such Trial shall be held in the State where the said Crimes shall have been committed; but when not committed within any State, the Trial shall be at such Place or Places as the Congress may by Law have directed.

SECTION 3 - TREASON NOTE

Treason against the United States, shall consist only in levying War against them, or in adhering to their Enemies, giving them Aid and Comfort. No Person shall be convicted of Treason unless on the Testimony of two Witnesses to the same overt Act, or on Confession in open Court.

The Congress shall have power to declare the Punishment of Treason, but no Attainder of Treason shall work Corruption of Blood, or Forfeiture except during the Life of the Person attainted.

ARTICLE IV. - THE STATES

SECTION 1 - EACH STATE TO HONOR ALL OTHERS

Full Faith and Credit shall be given in each State to the public Acts, Records, and judicial Proceedings of every other State. And the Congress may by general Laws prescribe the Manner in which such Acts, Records and Proceedings shall be proved, and the Effect thereof.

SECTION 2 - STATE CITIZENS, EXTRADITION

The Citizens of each State shall be entitled to all Privileges and Immunities of Citizens in the several States.

A Person charged in any State with Treason, Felony, or other Crime, who shall flee from Justice, and be found in another State, shall on demand of the executive Authority of the State from which he fled, be delivered up, to be removed to the State having Jurisdiction of the Crime.

(No Person held to Service or Labour in one State, under the Laws thereof, escaping into another, shall, in Consequence of any Law or Regulation therein, be discharged from such Service or Labour, But shall be delivered up on Claim of the Party to whom such Service or Labour may be due.) (This clause in parentheses is superseded by Amendment XIII.)

SECTION 3 - NEW STATES

New States may be admitted by the Congress into this Union; but no new States shall be formed or erected within the Jurisdiction of any other State; nor any State be formed by the Junction of two or more States, or parts of States, without the Consent of the Legislatures of the States concerned as well as of the Congress.

The Congress shall have Power to dispose of and make all needful Rules and Regulations respecting the Territory or other Property belonging to the United States; and nothing in this Constitution shall be so construed as to Prejudice any Claims of the United States, or of any particular State.

SECTION 4 - REPUBLICAN GOVERNMENT

The United States shall guarantee to every State in this Union a Republican Form of Government, and shall protect each of them against Invasion; and on Application of the Legislature, or of the Executive (when the Legislature cannot be convened) against domestic Violence.

ARTICLE V. - AMENDMENT

The Congress, whenever two thirds of both Houses shall deem it necessary, shall propose Amendments to this Constitution, or, on the Application of the Legislatures of two thirds of the several States, shall call a Convention for proposing Amendments, which, in either Case, shall be valid to all Intents and Purposes, as part of this Constitution, when ratified by the Legislatures of three fourths of the several States, or by Conventions in three fourths thereof, as the one or the other Mode of Ratification may be proposed by the Congress; Provided that no Amendment which may be made prior to the Year One thousand eight hundred and eight shall in any Manner affect the first and fourth Clauses in the Ninth Section of the first Article; and that no State, without its Consent, shall be deprived of its equal Suffrage in the Senate.

ARTICLE VI. - THE UNITED STATES

All Debts contracted and Engagements entered into, before the Adoption of this Constitution, shall be as valid against the United States under this Constitution, as under the Confederation.

This Constitution, and the Laws of the United States which shall be made in Pursuance thereof; and all Treaties made, or which shall be made, under the Authority of the United States, shall be the supreme Law of the Land; and the Judges in every State shall be bound thereby, any Thing in the Constitution or Laws of any State to the Contrary notwithstanding.

The Senators and Representatives before mentioned, and the Members of the several State Legislatures, and all executive and judicial Officers, both of the United States and of the several States, shall be bound by Oath or Affirmation, to support this Constitution; but no religious Test shall ever be required as a Qualification to any Office or public Trust under the United States.

ARTICLE VII. - RATIFICATION

The Ratification of the Conventions of nine States, shall be sufficient for the Establishment of this Constitution between the States so ratifying the Same.

Done in Convention by the Unanimous Consent of the States present the Seventeenth Day of September in the Year of our Lord

one thousand seven hundred and Eighty seven and of the Independence of the United States of America the Twelfth. In Witness whereof We have hereunto subscribed our Names.

Go Washington - President and deputy from Virginia

New Hampshire - John Langdon, Nicholas Gilman

Massachusetts - Nathaniel Gorham, Rufus King

Connecticut - Wm Saml Johnson, Roger Sherman

New York - Alexander Hamilton

New Jersey - Wil Livingston, David Brearley, Wm Paterson, Jona. Dayton

Pensylvania - B Franklin, Thomas Mifflin, Robt Morris, Geo. Clymer, Thos FitzSimons, Jared Ingersoll, James Wilson, Gouv Morris

Delaware - Geo. Read, Gunning Bedford jun, John Dickinson, Richard Bassett, Jaco. Broom

Maryland - James McHenry, Dan of St Tho Jenifer, Danl Carroll

Virginia - John Blair, James Madison Jr.

North Carolina - Wm Blount, Richd Dobbs Spaight, Hu Williamson

South Carolina - J. Rutledge, Charles Cotesworth Pinckney, Charles Pinckney, Pierce Butler

Georgia - William Few, Abr Baldwin

Attest: William Jackson, Secretary

THE AMENDMENTS

The following are the Amendments to the Constitution. The first ten Amendments collectively are commonly known as the Bill of Rights.

AMENDMENT I - FREEDOM OF RELIGION, PRESS, EXPRESSION. RATIFIED 12/15/1791.

Congress shall make no law respecting an establishment of religion, or prohibiting the free exercise thereof; or abridging the freedom of speech, or of the press; or the right of the people peaceably to assemble, and to petition the Government for a redress of grievances.

AMENDMENT II - RIGHT TO BEAR ARMS. RATIFIED 12/15/1791.

A well regulated Militia, being necessary to the security of a free State, the right of the people to keep and bear Arms, shall not be infringed.

AMENDMENT III - QUARTERING OF SOLDIERS. RATIFIED 12/15/1791.

No Soldier shall, in time of peace be quartered in any house, without the consent of the Owner, nor in time of war, but in a manner to be prescribed by law.

AMENDMENT IV - SEARCH AND SEIZURE. RATIFIED 12/15/1791.

The right of the people to be secure in their persons, houses, papers, and effects, against unreasonable searches and seizures, shall not be violated, and no Warrants shall issue, but upon probable cause, supported by Oath or affirmation, and particularly describing the place to be searched, and the persons or things to be seized.

AMENDMENT V - TRIAL AND PUNISHMENT, COMPENSATION FOR TAKINGS. RATIFIED 12/15/1791.

No person shall be held to answer for a capital, or otherwise infamous crime, unless on a presentment or indictment of a Grand Jury, except in cases arising in the land or naval forces, or in the Militia, when in actual service in time of War or public danger; nor shall any person be subject for the same offense to be twice put in jeopardy of life or limb; nor shall be compelled in any criminal case to be a witness against himself, nor be deprived of life, liberty, or property, without due process of law; nor shall private property be taken for public use, without just compensation.

AMENDMENT VI - RIGHT TO SPEEDY TRIAL, CONFRONTATION OF WITNESSES. RATIFIED 12/15/1791.

In all criminal prosecutions, the accused shall enjoy the right to a speedy and public trial, by an impartial jury of the State and dis-

trict wherein the crime shall have been committed, which district shall have been previously ascertained by law, and to be informed of the nature and cause of the accusation; to be confronted with the witnesses against him; to have compulsory process for obtaining witnesses in his favor, and to have the Assistance of Counsel for his defence.

AMENDMENT VII - TRIAL BY JURY IN CIVIL CASES. RATIFIED 12/15/1791.

In Suits at common law, where the value in controversy shall exceed twenty dollars, the right of trial by jury shall be preserved, and no fact tried by a jury, shall be otherwise re-examined in any Court of the United States, than according to the rules of the common law.

AMENDMENT VIII - CRUEL AND UNUSUAL PUNISHMENT. RATIFIED 12/15/1791.

Excessive bail shall not be required, nor excessive fines imposed, nor cruel and unusual punishments inflicted.

AMENDMENT IX - CONSTRUCTION OF CONSTITUTION. RATIFIED 12/15/1791.

The enumeration in the Constitution, of certain rights, shall not be construed to deny or disparage others retained by the people.

AMENDMENT X - STATES' RIGHTS. RATIFIED 12/15/1791.

The powers not delegated to the United States by the Constitution, nor prohibited by it to the States, are reserved to the States respectively, or to the people.

AMENDMENT XI - JUDICIAL LIMITS. RATIFIED 2/7/1795.

The Judicial power of the United States shall not be construed to extend to any suit in law or equity, commenced or prosecuted against one of the United States by Citizens of another State, or by Citizens or Subjects of any Foreign State.

AMENDMENT XII - CHOOSING THE PRESIDENT, VICE- PRESIDENT. RATIFIED 6/15/1804.

The Electors shall meet in their respective states, and vote by ballot for President and Vice- President, one of whom, at least, shall not be an inhabitant of the same state with themselves; they shall name in their ballots the person voted for as President, and in distinct ballots the person voted for as Vice-President, and they shall make distinct lists of all persons voted for as President, and of all persons voted for as Vice-President and of the number of votes for each, which lists they shall sign and certify, and transmit sealed to the seat of the government of the United States, directed to the President of the Senate;

The President of the Senate shall, in the presence of the Senate and House of Representatives, open all the certificates and the votes shall then be counted;

The person having the greatest Number of votes for President, shall be the President, if such number be a majority of the whole number of Electors appointed; and if no person have such majority, then from the persons having the highest numbers not exceeding three on the list of those voted for as President, the House of Representatives shall choose immediately, by ballot, the President. But in choosing the President, the votes shall be taken by states, the representation from each state having one vote; a quorum for this purpose shall consist of a member or members from two-thirds of the states, and a majority of all the states shall be necessary to a choice. And if the House of Representatives shall not choose a President whenever the right of choice shall devolve upon them, before the fourth day of March next following, then the Vice-President shall act as President, as in the case of the death or other constitutional disability of the President.

The person having the greatest number of votes as Vice-President, shall be the Vice-President, if such number be a majority of the whole number of Electors appointed, and if no person have a majority, then from the two highest numbers on the list, the Senate shall choose the Vice- President; a quorum for the purpose shall consist of two-thirds of the whole number of Senators, and a majority of the whole number shall be necessary to a choice. But no person constitutionally ineligible to the office of President shall be eligible to that of Vice-President of the United States.

AMENDMENT XIII - SLAVERY ABOLISHED. RATIFIED 12/6/1865.

1. Neither slavery nor involuntary servitude, except as a punishment for crime whereof the party shall have been duly convicted, shall exist within the United States, or any place subject to their jurisdiction.

2. Congress shall have power to enforce this article by appropriate legislation.

AMENDMENT XIV - CITIZENSHIP RIGHTS. RATIFIED 7/9/1868.

1. All persons born or naturalized in the United States, and subject to the jurisdiction thereof, are citizens of the United States and of the State wherein they reside. No State shall make or enforce any law which shall abridge the privileges or immunities of citizens

of the United States; nor shall any State deprive any person of life, liberty, or property, without due process of law; nor deny to any person within its jurisdiction the equal protection of the laws.

2. Representatives shall be apportioned among the several States according to their respective numbers, counting the whole number of persons in each State, excluding Indians not taxed. But when the right to vote at any election for the choice of electors for President and Vice-President of the United States, Representatives in Congress, the Executive and Judicial officers of a State, or the members of the Legislature thereof, is denied to any of the male inhabitants of such State, being twenty-one years of age, and citizens of the United States, or in any way abridged, except for participation in rebellion, or other crime, the basis of representation therein shall be reduced in the proportion which the number of such male citizens shall bear to the whole number of male citizens twenty-one years of age in such State.

3. No person shall be a Senator or Representative in Congress, or elector of President and Vice- President, or hold any office, civil or military, under the United States, or under any State, who, having previously taken an oath, as a member of Congress, or as an officer of the United States, or as a member of any State legislature, or as an executive or judicial officer of any State, to support the Constitution of the United States, shall have engaged in insurrection or rebellion against the same, or given aid or comfort to the enemies thereof. But Congress may by a vote of two-thirds of each House, remove such disability.

4. The validity of the public debt of the United States, authorized by law, including debts incurred for payment of pensions and bounties for services in suppressing insurrection or rebellion, shall not be questioned. But neither the United States nor any State shall assume or pay any debt or obligation incurred in aid of insurrection or rebellion against the United States, or any claim for the loss or emancipation of any slave; but all such debts, obligations and claims shall be held illegal and void.

5. The Congress shall have power to enforce, by appropriate legislation, the provisions of this article.

Amendment XV - Race no bar to vote. Ratified 2/3/1870.
1. The right of citizens of the United States to vote shall not be denied or abridged by the United States or by any State on account of race, color, or previous condition of servitude.

2. The Congress shall have power to enforce this article by appropriate legislation.

Amendment XVI - Income taxes authorized. Ratified 2/3/1913.
The Congress shall have power to lay and collect taxes on incomes, from whatever source derived, without apportionment among the several States, and without regard to any census or enumeration.

Amendment XVII - Senators elected by popular vote. Ratified 4/8/1913.
The Senate of the United States shall be composed of two Senators from each State, elected by the people thereof, for six years; and each Senator shall have one vote. The electors in each State shall have the qualifications requisite for electors of the most numerous branch of the State legislatures.

When vacancies happen in the representation of any State in the Senate, the executive authority of such State shall issue writs of election to fill such vacancies: Provided, That the legislature of any State may empower the executive thereof to make temporary appointments until the people fill the vacancies by election as the legislature may direct.

This amendment shall not be so construed as to affect the election or term of any Senator chosen before it becomes valid as part of the Constitution.

Amendment XVIII - Liquor abolished. Ratified 1/16/1919. Repealed by Amendment XXI, 12/5/1933.
1. After one year from the ratification of this article the manufacture, sale, or transportation of intoxicating liquors within, the importation thereof into, or the exportation thereof from the United States and all territory subject to the jurisdiction thereof for beverage purposes is hereby prohibited.

2. The Congress and the several States shall have concurrent power to enforce this article by appropriate legislation.

3. This article shall be inoperative unless it shall have been ratified as an amendment to the Constitution by the legislatures of the several States, as provided in the Constitution, within seven years from the date of the submission hereof to the States by the Congress.

Amendment XIX - Women's suffrage. Ratified 8/18/1920.
The right of citizens of the United States to vote shall not be denied or abridged by the United States or by any State on account of sex.

Congress shall have power to enforce this article by appropriate legislation.

Amendment XX - Presidential, Congressional terms. Ratified 1/23/1933.

1. The terms of the President and Vice President shall end at noon on the 20th day of January, and the terms of Senators and Representatives at noon on the 3d day of January, of the years in which such terms would have ended if this article had not been ratified; and the terms of their successors shall then begin.

2. The Congress shall assemble at least once in every year, and such meeting shall begin at noon on the 3d day of January, unless they shall by law appoint a different day.

3. If, at the time fixed for the beginning of the term of the President, the President elect shall have died, the Vice President elect shall become President. If a President shall not have been chosen before the time fixed for the beginning of his term, or if the President elect shall have failed to qualify, then the Vice President elect shall act as President until a President shall have qualified; and the Congress may by law provide for the case wherein neither a President elect nor a Vice President elect shall have qualified, declaring who shall then act as President, or the manner in which one who is to act shall be selected, and such person shall act accordingly until a President or Vice President shall have qualified.

4. The Congress may by law provide for the case of the death of any of the persons from whom the House of Representatives may choose a President whenever the right of choice shall have devolved upon them, and for the case of the death of any of the persons from whom the Senate may choose a Vice President whenever the right of choice shall have devolved upon them.

5. Sections 1 and 2 shall take effect on the 15th day of October following the ratification of this article.

6. This article shall be inoperative unless it shall have been ratified as an amendment to the Constitution by the legislatures of three-fourths of the several States within seven years from the date of its submission.

Amendment XXI - Amendment XVIII repealed. Ratified 12/5/1933.

1. The eighteenth article of amendment to the Constitution of the United States is hereby repealed.

2. The transportation or importation into any State, Territory, or possession of the United States for delivery or use therein of intoxicating liquors, in violation of the laws thereof, is hereby prohibited.

3. The article shall be inoperative unless it shall have been ratified as an amendment to the Constitution by conventions in the several States, as provided in the Constitution, within seven years from the date of the submission hereof to the States by the Congress.

Amendment XXII - Presidential terms limits. Ratified 2/27/1951.

1. No person shall be elected to the office of the President more than twice, and no person who has held the office of President, or acted as President, for more than two years of a term to which some other person was elected President shall be elected to the office of the President more than once. But this Article shall not apply to any person holding the office of President, when this Article was proposed by the Congress, and shall not prevent any person who may be holding the office of President, or acting as President, during the term within which this Article becomes operative from holding the office of President or acting as President during the remainder of such term.

2. This article shall be inoperative unless it shall have been ratified as an amendment to the Constitution by the legislatures of three-fourths of the several States within seven years from the date of its submission to the States by the Congress.

Amendment XXIII - Presidential vote for District of Columbia. Ratified 3/29/1961.

1. The District constituting the seat of Government of the United States shall appoint in such manner as the Congress may direct: A number of electors of President and Vice President equal to the whole number of Senators and Representatives in Congress to which the District would be entitled if it were a State, but in no event more than the least populous State; they shall be in addition to those appointed by the States, but they shall be considered, for the purposes of the election of President and Vice President, to be electors appointed by a State; and they shall meet in the District and perform such duties as provided by the twelfth article of amendment.

2. The Congress shall have power to enforce this article by appropriate legislation.

Amendment XXIV - Poll tax barred. Ratified 1/23/1964.

1. The right of citizens of the United States to vote in any primary or other election for President or Vice President, for electors for President or Vice President, or for Senator or Representative in Congress, shall not be denied or abridged by the United States or any State by reason of failure to pay any poll tax or other tax.

2. The Congress shall have power to enforce this article by appropriate legislation.

Amendment XXV - Presidential disability and succession. Ratified 2/10/1967.

1. In case of the removal of the President from office or of his death or resignation, the Vice President shall become President.

2. Whenever there is a vacancy in the office of the Vice President, the President shall nominate a Vice President who shall take office upon confirmation by a majority vote of both Houses of Congress.

3. Whenever the President transmits to the President pro tempore of the Senate and the Speaker of the House of Representatives his written declaration that he is unable to discharge the powers and duties of his office, and until he transmits to them a written declaration to the contrary, such powers and duties shall be discharged by the Vice President as Acting President.

4. Whenever the Vice President and a majority of either the principal officers of the executive departments or of such other body as Congress may by law provide, transmit to the President pro tempore of the Senate and the Speaker of the House of Representatives their written declaration that the President is unable to discharge the powers and duties of his office, the Vice President shall immediately assume the powers and duties of the office as Acting President.

Thereafter, when the President transmits to the President pro tempore of the Senate and the Speaker of the House of Representatives his written declaration that no inability exists, he shall resume the powers and duties of his office unless the Vice President and a majority of either the principal officers of the executive department or of such other body as Congress may by law provide, transmit within four days to the President pro tempore of the Senate and the Speaker of the House of Representatives their written declaration that the President is unable to discharge the powers and duties of his office. Thereupon Congress shall decide the issue, assembling within forty eight hours for that purpose if not in session. If the Congress, within twenty one days after receipt of the latter written declaration, or, if Congress is not in session, within twenty one days after Congress is required to assemble, determines by two thirds vote of both Houses that the President is unable to discharge the powers and duties of his office, the Vice President shall continue to discharge the same as Acting President; otherwise, the President shall resume the powers and duties of his office.

Amendment XXVI - Voting age set to 18 years. Ratified 7/1/1971.

1. The right of citizens of the United States, who are eighteen years of age or older, to vote shall not be denied or abridged by the United States or by any State on account of age.

2. The Congress shall have power to enforce this article by appropriate legislation.

Amendment XXVII - Congressional pay increases. Ratified 5/7/1992.

No law, varying the compensation for the services of the Senators and Representatives, shall take effect, until an election of Representatives shall have intervened.

GOD BLESS AMERICA

While the storm clouds gather
Far across the sea,
Let us swear allegiance
To a land that's free;
Let us all be grateful
For a land so fair,
As we raise our voices
In a solemn prayer.

God bless America
Land that I love,
Stand beside her and guide her
Thru the night with a light from above;
From the mountains to the prairies,
To the oceans white with foam,
God bless America
My home sweet home.

Irving Berlin

AMERICA THE BEAUTIFUL

O beautiful for spacious skies,
For amber waves of grain,
For purple mountain majesties
Above the fruited plain!
 America! America!
God shed his grace on thee,
And crown thy good with brotherhood
From sea to shining sea!

O beautiful for pilgrim feet,
Whose stern impassioned stress
A thoroughfare for freedom beat
Across the wilderness!
 America! America!
God mend thine every flaw,
Confirm thy soul in self-control,
Thy liberty in law!

O beautiful for heroes proved
In liberating strife,
Who more than self their country loved,
And mercy more than life!
 America! America!
May God thy gold refine,
Till all success be nobleness
And every gain divine!

O beautiful for patriot dream
That sees beyond the years
Thine alabaster cities gleam,
Undimmed by human tears!
 America! America!
God shed his grace on thee,
And crown thy good with brotherhood
From sea to shining sea!

Katherine L. Bates

215

MY COUNTRY, 'TIS OF THEE

My country, 'tis of thee,
Sweet land of liberty,
Of thee I sing:
 Land where my fathers died,
 Land of the pilgrims' pride,
 From every mountainside
Let freedom ring!

My native country, thee,
Land of the noble free,
Thy name I love:
 I love thy rock and rills,
 Thy woods and templed hills;
 My heart with rapture thrills
Like that above.

Let music swell the breeze,
And ring from all the trees
Sweet freedom's song:
 Let mortal tongues awake,
 Let all that breathe partake;
 Let rocks their silence break,
The sound prolong.

Our fathers' God, to thee,
Author of liberty,
To thee we sing;
 Long may our land be bright
 With freedom's holy light;
 Protect us by thy might,
Great God, our King!

Samuel Francis Smith

THE STAR-SPANGLED BANNER

Oh! say, can you see, by the dawn's early light,
What so proudly we hailed at the twilight's last gleaming?
Whose broad stripes and bright stars, thro' the perilous fight,
O'er the ramparts we watched were so gallantly streaming?
And the rockets red glare, the bombs bursting in air,
Gave proof through the night that our flag was still there.
Oh, say does that star-spangled banner yet wave,
O'er the land of the free and the home of the brave?

On the shore, dimly seen thro' the mist of the deep,
Where the foe's haughty host in dread silence reposes,
What is that which the breeze, o'er the towering steep,
As it fitfully blows, half conceals, half discloses?
Now it catches the gleam of the morning's first beam,
In full glory reflected, now shines on the stream.
'Tis the star-bangled banner. Oh! long may it wave
O'er the land of the free and the home of the brave!

And where is that band who so vauntingly swore
That the havoc of war and the battle's confusion
A home and a country should leave us no more?
Their blood has washed out their foul footstep's pollution.
No refuge could save the hireling and slave
From the terror of flight or the gloom of the grave,
And the star-spangled banner in triumph doth wave
O'er the land of the free and the home of the brave.

Oh! thus be it ever when free men shall stand
Between their loved ones and the war's desolation,
Blest with vict'ry and peace, may the Heav'n rescued land
Praise the Pow'r that hath made and preserved us a nation.
Then conquer we must, when our cause it is just,
And this be our motto, "In God is our trust."
And the star-spangled banner in triumph shall wave
O'er the land of the free and the home of the brave.

Francis Scott Key

FLAG FOLDING CEREMONY

As an Army and Navy custom, the flag is lowered daily at the last note of retreat. Special care should be taken that no part of the flag touches the ground. The flag is then carefully folded into the shape of a tri-cornered hat, emblematic of the hats worn by colonial soldiers during the War for Independence. In the folding, the red and white stripes are finally wrapped into the blue, as the light of day vanishes into the darkness of night.

This custom of special folding is reserved for the United States Flag alone.

The flag folding ceremony represents the same religious principles on which our country was originally founded. The portion of the flag denoting honor is the canton of blue containing the stars representing the states of our veterans who served in uniform. The canton field of blue dresses from left to right and is inverted when draped as a pall on a casket of a veteran who has served our country in uniform.

In the Armed Forces of the United States, at the ceremony of retreat the flag is lowered, folded in a triangle fold and kept under watch throughout the night as a tribute to our nation's honored dead. The next morning, it is brought out and, at the ceremony of reveille, run aloft as a symbol of our belief in the resurrection of the body.

The first fold of our flag is a symbol of life.

The second fold is a symbol of our belief in the eternal life.

The third fold is made in honor and remembrance of the veteran departing our ranks who gave a portion of life for the defense of our country to attain a peace throughout the world.

The fourth fold represents our weaker nature, for as American citizens trusting in God, it is to him we turn in times of peace as well as in times of war for His divine guidance.

The fifth fold is a tribute to our country, for in the words of Stephen Decatur, "Our country, in dealing with other countries, may she always be right; but it is still our country, right or wrong."

The sixth fold is for where our hearts lie. It is with our heart that we pledge allegiance to the flag of the United States of America, and to the republic for which it stands, one nation, under God, indivisible, with liberty and justice for all.

The seventh fold is a tribute to our Armed Forces, for it is through the Armed Forces that we protect our country and our flag against all her enemies, whether they be found within or without the boundaries of our republic.

The eighth fold is a tribute to the one who entered into the valley of the shadow of death, that we might see the light of day, and to honor mother, for whom it flies on mother's day.

The ninth fold is a tribute to womanhood; for it has been through their faith, love, loyalty and devotion that the character of the men and women who have made this country great have been molded.

The tenth fold is a tribute to father, for he, too, has given his sons and daughters for the defense of our country since they were first born.

The eleventh fold, in the eyes of a Hebrew citizen, represents the lower portion of the seal of King David and King Solomon, and glorifies, in their eyes, the God of Abraham, Isaac, and Jacob.

The twelfth fold, in the eyes of a Christian citizen, represents an emblem of eternity and glorifies, in their eyes, God the Father, the Son, and Holy Ghost.

When the flag is completely folded, the stars are uppermost, reminding us of our national motto, "In God we Trust."

After the flag is completely folded and tucked in, it takes on the appearance of a cocked hat, ever reminding us of the soldiers who served under General George Washington and the sailors and marines who served under Captain John Paul Jones who were followed by their comrades and shipmates in the Armed Forces of the United States, preserving for us the rights, privileges, and freedoms we enjoy today.

from the U.S. Air Force Academy

This is an e-mail (9-14-01) from a young ensign aboard the *USS Winston Churchill*.

DEAR DAD, WE ARE STILL AT SEA. The remainder of our port visits have all been cancelled. We have spent every day since the attacks going back and forth within imaginary boxes drawn in the ocean, standing high-security watches, and trying to make the best of it. We have seen the articles and the photographs, and they are sickening. Being isolated, I don't think we appreciate the full scope of what is happening back home, but we are definitely feeling the effects. About two hours ago, we were hailed by a German Navy Destroyer, *Lutjens*, requesting permission to pass close by our port side. Strange, since we're in the middle of an empty ocean, but the captain acquiesced and we prepared to render them honors from our bridge wing. As they were making their approach, our conning officer used binoculars and announced that *Lutjens* was flying not the German, but the American flag. As she came alongside us, we saw the American flag flying half-mast and her entire crew topside standing at silent, rigid attention in their dress uniforms. They had made a sign that was displayed on her side that read "We Stand By You." There was not a dry eye on the bridge as they stayed alongside us for a few minutes and saluted. It was the most powerful thing I have seen in my life. The German Navy did an incredible thing for this crew, and it has truly been the highest point in the days since the attacks. It's amazing to think that only a half-century ago things were quite different. After *Lutjens* pulled away, the Officer of the Deck, who had been planning to get out later this year, turned to me and said, "I'm staying Navy." I'll write you when I know more about when I'll be home, but this is it for now. Love you guys.

(compliments of www.navy.mil)

ENGRAVED ON GRANITE NEAR PRESIDENT JOHN F. KENNEDY'S GRAVESITE, FROM HIS INAUGURAL ADDRESS

Let the word go forth from this time and place to friend and foe alike,
that the torch has been passed to a new generation of Americans.

Let every nation know whether it wishes us well or ill
that we shall pay any price, bear any burden, meet any hardship,
support any friend, oppose any foe
to assure the survival and success of liberty.

Now the trumpet summons us again
not as a call to arms, though arms we need,
not as a call to battle, though embattled we are,
but as a call to bear the burden of a long twilight struggle,
a struggle against the common enemies of man,
tyranny, poverty, disease and war itself.

In the long history of the world
only a few generations have been granted the roll of defending freedom
in its hour of maximum danger.
I do not shrink from this responsibility,
I welcome it.

The energy, the faith, the devotion which we bring to this endeavor
will light our country and all who serve it,
and the glow from that fire can truly light the world.

And so my fellow Americans, ask not what your country can do for you,
ask what you can do for your country.
My fellow citizens of the world, ask not what America can do for you,
but what together we can do for the freedom of man.

With good conscience our only sure reward,
with history the final judge of our deeds,
let us go forth to lead the land we love,
asking His blessing and His help,
but knowing that here on earth God's work must surely be our own.

I AM AN AMERICAN.

My father belongs to the Sons of the American Revolution;
My mother, to the Colonial Dames.
One of my ancestors pitched tea overboard in Boston Harbor;
Another stood his ground with Warren;
Another hungered with Washington at Valley Forge.
My forefathers were America in the making;
They spoke in her council halls;
The died on her battlefields;
They commanded her ships;
They cleared her forests.
Dawns reddened and paled.
Staunch hearts of mine beat fast at each new star
In the nation's flag.
Keen eyes of mine foresaw her greater glory:
The sweep of her seas,
The plenty of her plains,
The man-hives of her billion-wired cities.
Every drop of blood in me holds a heritage of patriotism.
I am proud of my past.
I am an American.

I am an American.
My father was an atom of dust,
My mother a straw in the wind,
To his serene majesty.
One of my ancestors died in the mines of Siberia;
Another was crippled for life by twenty blows of the knout;
Another was killed for defending his home during the massacres.
The history of my ancestors is a trail of blood
To the palace of the Great White Czar.
But then the dream came,
The dream of America.
In the light of the Liberty torch
The atom of dust became a man
And the straw in the wind a woman
For the first time.

"See," said my father, pointing to the flag that fluttered near,
"That flag of stars and stripes in yours;
It is the emblem of the promised land.
It means, my son, the hope of humanity.
Live for it, die for it!"
Under the open sky of my new country I swore to do so;
And every drop of blood in me will keep that vow.
I am proud of my future.

I am an American

Elias Leiberman